IMAGES
of America

CHELSEA

IN THE 20TH CENTURY

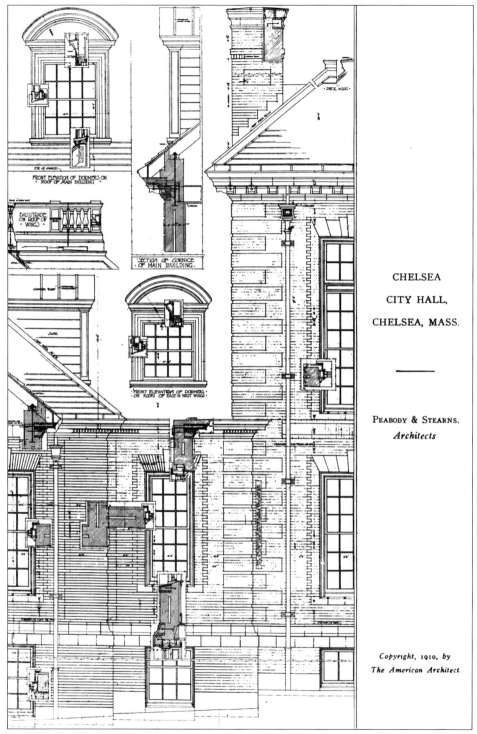

CHELSEA
CITY HALL,
CHELSEA, MASS.

———

PEABODY & STEARNS.
Architects

This 1910 blueprint drawing of the Chelsea City Hall, designed by the firm of Peabody & Stearns, is from *American Architect Magazine*. (Courtesy of Historic New England/The Society for the Preservation of New England Antiquities.)

IMAGES
of America

CHELSEA
IN THE 20TH CENTURY

Margaret Harriman Clarke

ARCADIA
PUBLISHING

Published by Arcadia Publishing
Charleston, South Carolina

Printed in the United States of America

Library of Congress Catalog Card Number: 2004105630

For all general information contact Arcadia Publishing at:
Telephone 843-853-2070
Fax 843-853-0044
E-mail sales@arcadiapublishing.com
For customer service and orders:
Toll-Free 1-888-313-2665

Visit us on the Internet at www.arcadiapublishing.com

Dedicated to my friends and classmates from Chelsea, who welcomed me when I was a shy newcomer and made life fun. For those who are no longer with us, happy memories remain.

CONTENTS

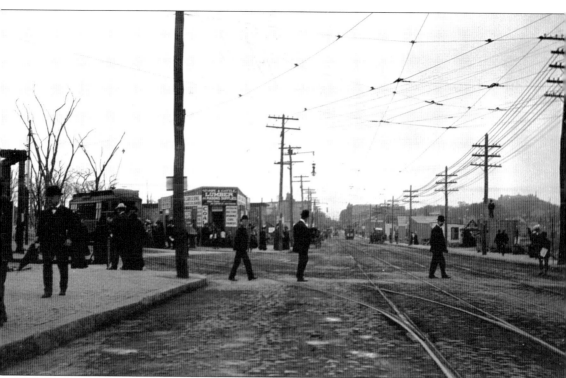

Bellingham Square is shown in a view that looks down Broadway toward the Mystic River. This is the sight that welcomed returning Chelsea residents shortly after the devastating fire of April 12, 1908. One of the busiest thoroughfares in the city was all but demolished. With the courage and determination that they have long been known for, Chelsea residents rallied as never before to help with the rebuilding and rebirth of their beloved city. Within a few years, a new and better Broadway lay before them, as modern shops replaced the old and life bustled along into the 20th century. (Courtesy of the Chelsea Public Library.)

INTRODUCTION

In the late 19th century, the city of Chelsea had begun its change from the "new and delightful village" of 1830 to one of the most densely settled cities in America. The first immigrants to arrive in the city were from England, Ireland, and Canada. Their assimilation was not especially difficult because of the common language and cultural similarities. The next wave of newcomers, however, was from southern and eastern Europe, which meant a dramatic and unexpected increase in the Russian, Polish, and Italian population.

In 1910, some 22 percent of the population of Chelsea was foreign born. Since many factories had relocated here, it appeared that there would be plenty of employment opportunities. In 1915, there were over 100 manufacturers in Chelsea; Revere Rubber Company and A. G. Walton Shoe combined employed more than 2,000 workers, most of them local citizens. A full two-thirds of the population worked in the city. With affordable housing, good schools, and plenty of jobs, Chelsea became a rich example of the pursuit and fulfillment of the American Dream.

Chelsea also had an excellent waterfront; shipbuilding, lumberyards, metalwork, and paint companies flourished along Marginal Street. Accessible railroad lines made delivering raw materials and collecting finished products an efficient task. Unfortunately, the noxious nature of these businesses turned this delightful early residential neighborhood into a less desirable place to live.

In his 1916 inaugural address, Mayor Malone was proud to proclaim that the city had no debts; all bills accrued in 1915 were paid in 1915. Unfortunately, it was to be the last time that statement could be made. The first of the Williams School additions, which cost $125,000, had just been completed, and running the schools was expensive. The overcrowded high school was put on two sessions. The mayor complained that there were too many pleas to the Poor Department for financial assistance, which that year had cost the city $25,000. Chelsea was still reconstructing streets and sidewalks that had been ruined in the 1908 fire. With a population of over 43,000, the mayor needed to run a tight ship to keep expenses under control.

Lawrence F. Quigley's terms as mayor in the 1920s typified the changes that the political system was undergoing during this time. In what likely seemed harmless, jobs were handed out to unqualified persons to whom he owed favors. This patronage system was not uncommon, but it had a serious impact on the city's modest budget. Even with the job opportunities that were available, unemployment was high. When Mayor Whalen was elected in 1927, he tried to pull the city back in line financially. His one term was not enough to make a change, and Quigley was reelected again in 1928. People regarded Quigley as a man who cared about them. Recognizing the importance of sports in children's lives, he called for playgrounds around the city. He paved Marginal Street to divert traffic from Broadway, put traffic signals in Bellingham Square, suggested an incinerator for the Williams Street dump, and began a dental clinic for schoolchildren. Not a proponent of Prohibition, he nevertheless expected that the law should

be upheld. It is reported that, along with Celtic, he spoke Yiddish and Italian. Visible and approachable, he was typical of the new style of governing in the 20th century. No longer was it the patriarchal Yankee system of earlier times; no longer was it "no Irish need apply."

With the countrywide Depression in the 1930s, it was difficult for any city to keep up with the needs of its people. The one program that helped Chelsea a great deal at this time was the federal Works Progress Administration, commonly called the WPA. The WPA hired the unemployed to perform assorted necessary city improvements. Many of Chelsea's streets, sidewalks, and parks were upgraded under this program. The cobblestones that are still visible on some streets were laid during the 1930s. To complete this work, the city purchased two new trucks, totaling $1,250, one each from Chelsea Square Chevrolet and one at Ullian Motor Sales, two familiar names in the city's popular automobile trade.

The 1940s also had its set of challenges. The male work force was seriously reduced because of the many young men serving in the armed forces. Women who replaced them in their jobs enjoyed a freedom they had never known. Working out of necessity, their actions laid the seeds for later demands for equality in the workplace. The restrictions on food, clothing, and gasoline in the war years gave way to a new optimism when the war was over. In his 1946 inaugural address, Mayor Bernard Sullivan declared that we were "on the threshold of what should be the greatest period of prosperity and accomplishment this country and the world had ever known." He continued, "The energy used in the war effort could be channeled and harnessed in peace efforts to improve the national well being of every man, woman, and child."

In the ensuing years, Chelsea's population declined to 36,000, but its expenses did not similarly follow. The continual upkeep of the streets, schools, and city services was a struggle. As use of the automobile increased, more parking was needed to keep people shopping in Chelsea. Each problem triggered yet another expense. Homes that were demolished for the building of the Mystic River Bridge in the late 1940s created a housing shortage in the already crowded city. In an attempt to solve this, plans were developed to build veterans' and low-income housing where land was available.

Andrew P. Quigley inherited a whole set of problems in 1952, when he entered the office his father had held for many years. Never a proponent of the new bridge, he believed business would be lost because cars were no longer going through Chelsea, but rather over it. Tax rates were high due to the many automobile accidents, and Prattville School was overcrowded while Williams was partly empty. When the new housing project was completed on Clinton Street, there was the possibility that the Mary C. Burke School would be overcrowded as well. The odious clay pit continued to be a neighborhood nuisance. Quigley had his hands full.

Yet, the 1950s felt like some of the best times in the city. There remained a mixed ethnic population, including many first- and second-generation Americans. For all of its faults, they had become very attached to Chelsea. It did not seem to matter if you drove a taxi or worked in a bank. Friendships made over the years were strong, as was loyalty to the city. Outside criticism was not welcomed. You could go to Boston to shop if you wanted to—but you could find almost anything you needed right in Chelsea. Staying this close to home created a high interest in local news and activities. That special trait, that small-town feeling of Chelsea, has always been much of its appeal.

People rose to the challenges and adjusted to the stresses of each decade. While adults worried about the rise of Communism and juvenile delinquency in the 1950s, for others it was the decade of the teenager. A newly emancipated group, the teens were committed to having as much fun as a day could hold. What was happening at Tony's Spa, the Olympia Theatre, or the bowling alley was their major concern. If Chelsea won the Thanksgiving Day football game and you had a date for the prom, life was good.

From the disastrous fire of 1908 to the challenges of the 1950s—these are the years portrayed in the second volume on this most interesting of American cities. I hope the photographs herein bring pleasure and fond memories to those who have lived here and enjoyed the city firsthand. For newcomers, welcome! Take care of the city as if it were your own.

One

FIRE!

"As the sky grew light and the morning mist cleared away, it disclosed a vast expanse of smoking ruins. The night had passed, and what a night; filled with vivid, awful memories of the dead and injured, the homeless and destitute. The great blackened tract over which the fire had swept, which only the day before had been covered with dwellings, stores, and public buildings was deserted, save for the soldiers, and here and there little groups of firemen, tired and worn out, still working. As far as one could see lay nothing but a barren waste, with here and there the ragged walls of a church or school standing out against the sky like the ruins of some old castle." (Quote from eyewitness John P. Nolan, dated April 13, 1908.)

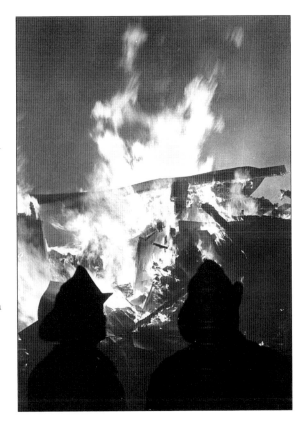

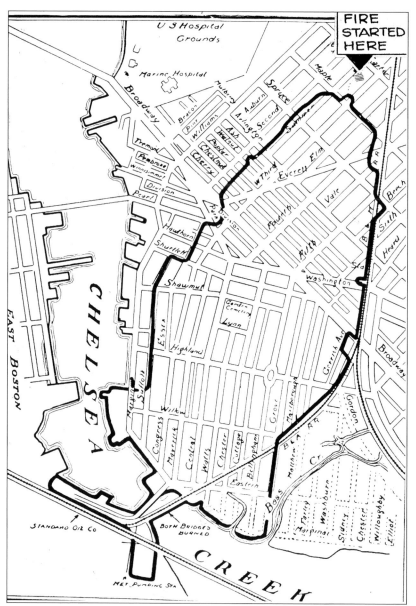

FIRE STARTED HERE

April 12, 1908, was a blustery Palm Sunday and the beginning of spring. A spark is caught by the wind, and a small fire, undetected, grows larger. Soon, the flames are out of control. Later, investigation determined that the fire began at 241 Second Street, the first alarm being struck at 10:44 a.m. It was a moment that changed the course of history in the small, densely populated city of Chelsea. The wind whipped the flames up Everett Avenue and along Broadway toward Bellingham Square. They raced through Park Square, down Essex Street and Central Avenue. As block after block fell, it seemed as if the fire would never stop. The old high school and the beautiful estates on Bellingham Street were not spared. It was only when the fire reached the railroad tracks, just past St. Rose Church, that the flames were brought under control. There was a tremendous loss of property, and thousands were made homeless, but only 19 people died—a miracle for a fire so devastating. (Courtesy of the *Boston Herald*, hereinafter called BH.)

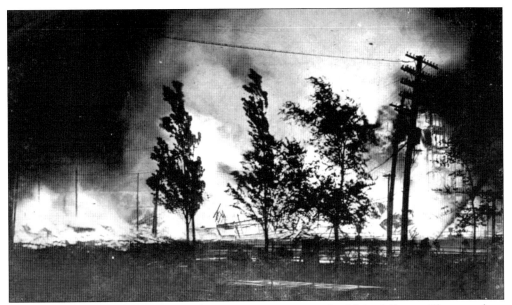

Word of the terrific fire was carried in newspapers across the United States. Photographers raced to the scene to take photographs, which were later made into postcards to commemorate the event. It is hard to imagine the terror in facing a scene such as that pictured above. Along with more than 2,800 buildings, 700-plus of the city's shade trees were destroyed. (Courtesy of Charlie MacFarlane, hereinafter called CM.)

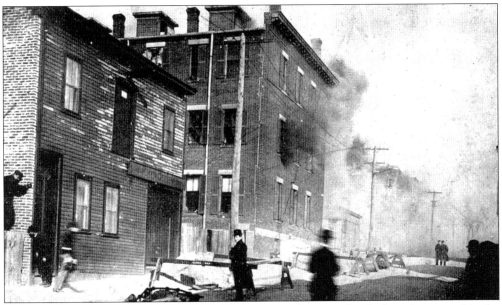

Not realizing what was happening from one moment to the next, shocked residents stood in the midst of the smoke, unsure of what to do. The fire roared up Essex Street and along Marginal Street to the bridge at Eastern Avenue and then across town to the carbarns at the corner of Gerrish Avenue and Broadway. In total, nearly 500 acres of the small city burned. (Courtesy of the Chelsea Public Library, hereinafter called CPL.)

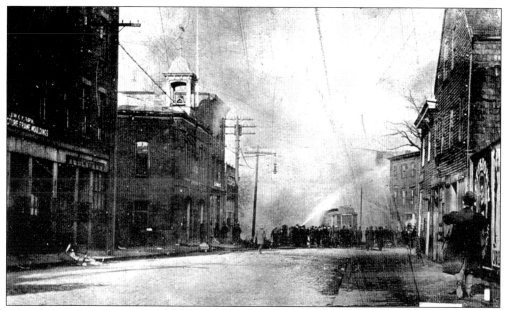

The Chelsea Square end of Park Street was mostly spared, leaving intact the Gerrish Block, where Abraham Lincoln spoke in the 1840s. The second building on the left is Chelsea Engine No. 1, which also escaped the flames. The 1902 Central Fire Station and Hose No. 3 were not as fortunate. There were still many old wooden buildings in the city, which went up like matchsticks. (Courtesy of CPL.)

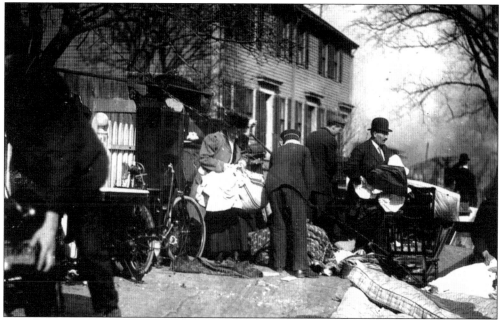

Hoping to save some of their possessions, these families on Park Street have pulled furniture, mattresses, and a bicycle out into the street. Probably having just returned from church services, the men are still properly dressed in white shirts, neckties, and hats. Most likely, a large Sunday dinner was about to be put on the table. (Courtesy of the Boston Public Library Print Department, hereinafter called BPL.)

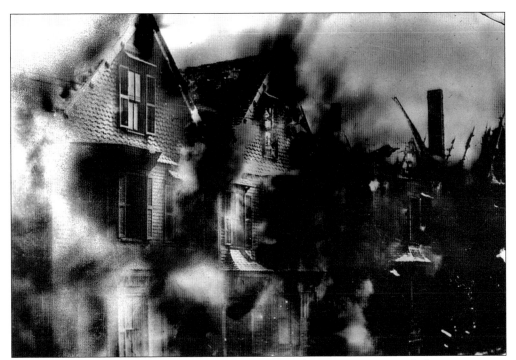

Here is another terrifying sight of people waiting too long to evacuate and then attempting to save a few possessions. These mid-to-late-19th-century shingled homes were typical of the houses that dotted the area before the fire. Many of the same modest, middle-class residences can still be found throughout the city. (Courtesy of BH.)

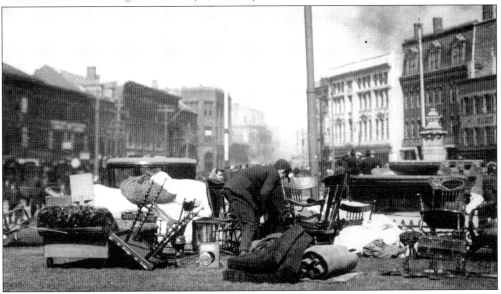

Although damaged during the fire, Chelsea Square, the oldest part of the city, was not demolished. Most buildings are still recognizable today, including the white building, which was formerly the Chelsea Post Office. Once this area appeared safe from the flames, people brought what household goods they could carry and stored them near the recently erected Stebbins fountain. (Courtesy of BPL.)

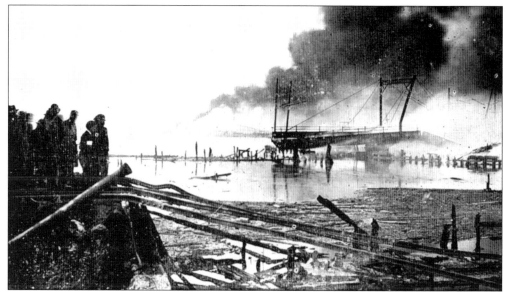

A crowd along Marginal Street watches as the old Chelsea Bridge along Eastern Avenue goes up in flames. Nearby, the Samuel Cabot Paint Company, with its highly flammable oils and paints, was also demolished in the fire. Like many local companies, it rebuilt and carried on business here for many more years. (Courtesy of CPL.)

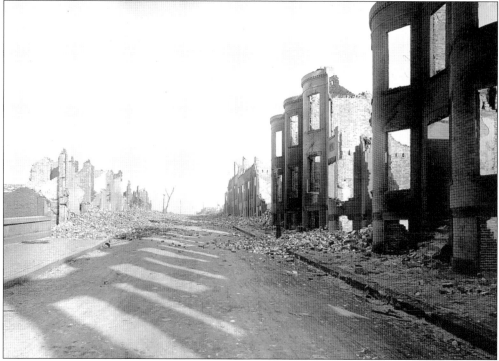

This dramatic view of the sun coming through the window openings of a row of burned-out brick bow fronts looks like a scene from a bombed village in wartime. More than 2,800 buildings were destroyed. The total fire loss was estimated at $17 million, about half of which was covered by insurance. (Courtesy of BH.)

14

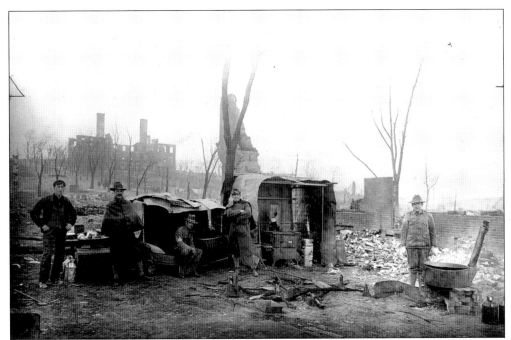

After the fire, the militia was called in to protect people and property. The men set up their tents and makeshift kitchens along the railroad tracks and brought a sense of order and control amidst the chaos. Of the 16,000 people who were burned out of their homes, about half were able to stay in the city with friends and relatives. Some took the opportunity to move away; others returned as they were able, and the population dropped only slightly. (Courtesy of BH and BPL.)

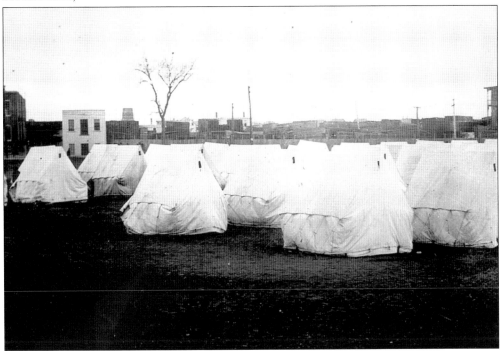

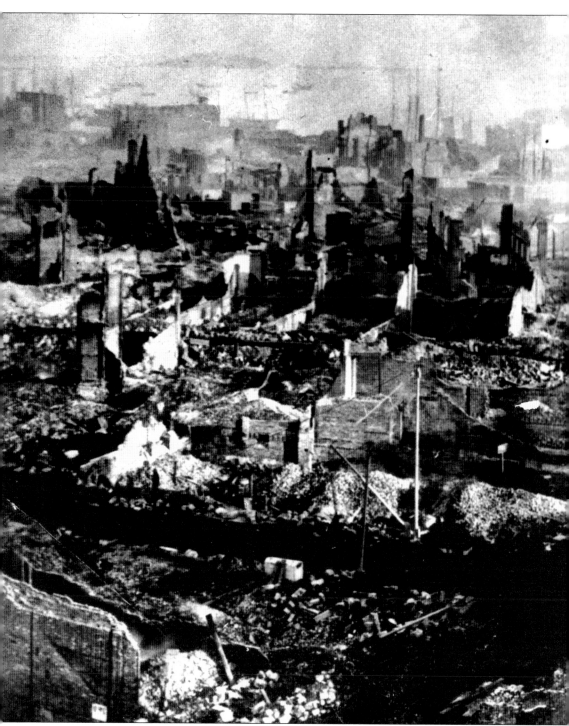

Another incredible view of the devastation, this photograph was taken looking down Shawmut Street toward the water. Shawmut Street curves just as it intersects with Central Avenue, at the right in the photograph. Fortunately, the fire did not burn the stretch of Marginal Street, in the distance. Note the very faint image of ships in the waters of Chelsea Creek. The Chelsea City

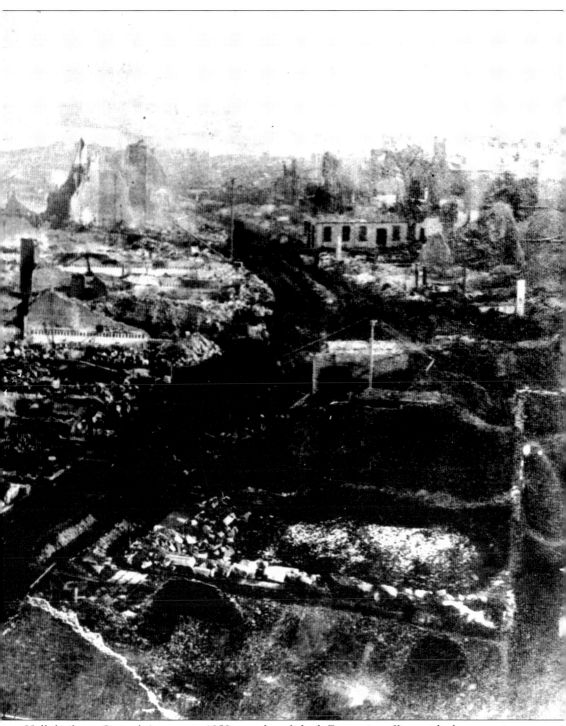

Hall, built on Central Avenue in 1853, was demolished. Every city office, with the exception of the police, electrician, overseers of the poor, and license commission, was destroyed—all of the furniture and records went up in smoke. (Courtesy of BH.)

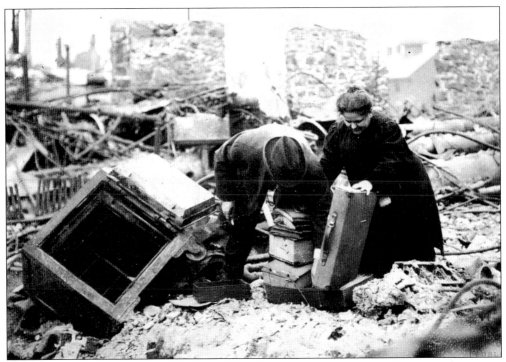

The merchants above are checking the contents of their safe, which appear to be intact, amidst the debris of their store on Broadway. The entire shopping district had to be rebuilt. The children below have made a successful trip to the main relief station, which was set up at the high school. Mattresses were one of the very basic necessities in the days following the fire, having been either burned or ruined by the fire hoses. (Courtesy of BPL.)

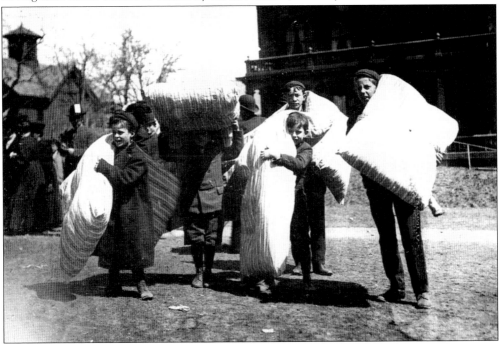

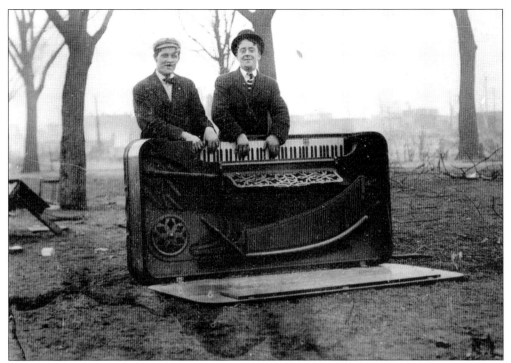

These two groups seem to be making the best of a most difficult situation—call it the Chelsea trait of bouncing back from adversity. The hand-lettered caption on the photograph reads, "A piano solo midst the ruins." The trio below also manage a smile as they clutch some new household goods, standing in front of the Soldiers' Monument in Union Park on Sixth Street. In 1911, the monument was placed in front of the new Chelsea City Hall. (Courtesy of BPL.)

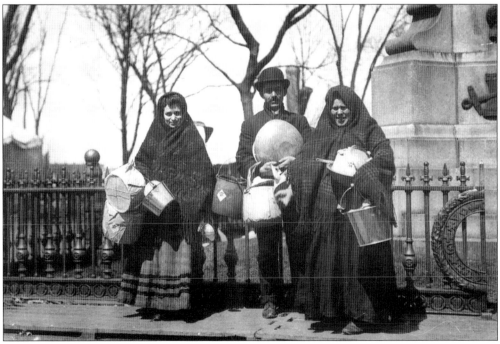

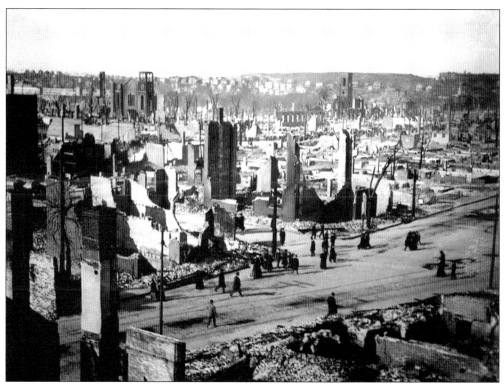

Again, it is almost impossible to imagine the destruction that occurred during the fire. The main street in this photograph appears to be Broadway, with the ruins of the Universalist Church, located at Fourth and Chestnut Streets, at the left center. In the center of the image below are the remains of St. Rose Church, with the high school to the right on Crescent Avenue. In the foreground is Bellingham Street. (Courtesy of BPL and BH.)

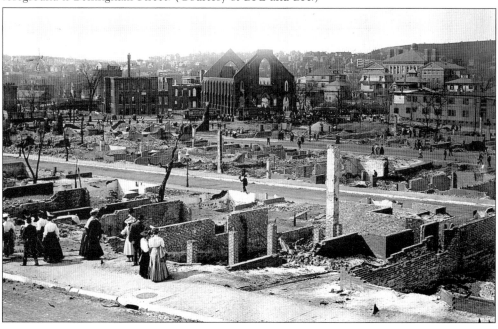

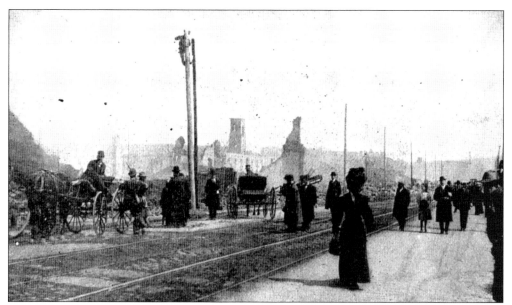

Here is one last look at Broadway—the upper view is from the Bellingham Square end of Broadway, looking toward Chelsea Square. In the lower view are the remains of the Chelsea Trust Company building, at the corner of Everett Avenue. There was a great influx of sightseers when the fire was over. For a while, Chelsea became quite a tourist attraction. Soon, new life came to this area, with modern stores offering everything the local population wanted. (Courtesy of CPL and BPL.)

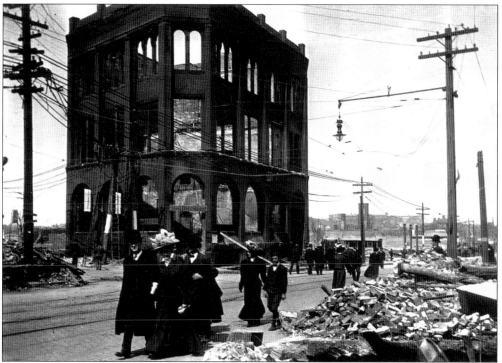

Before they could rest their weary heads, many residents were faced with more difficult times. For some, there was only enough energy left for a few tears; the above caption reads "Homeless." For Mother, however, there was Passover to prepare for, which she was able to do with grateful thanks for supplies donated by the Young Men's Hebrew Association. (Courtesy of BPL.)

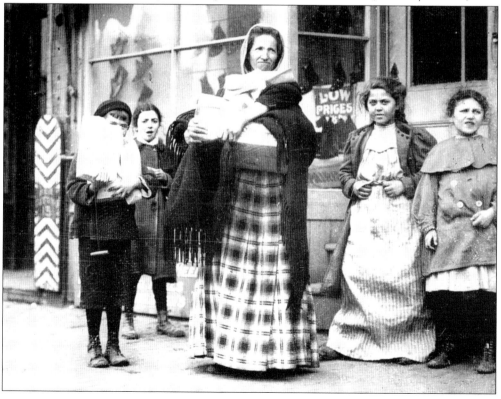

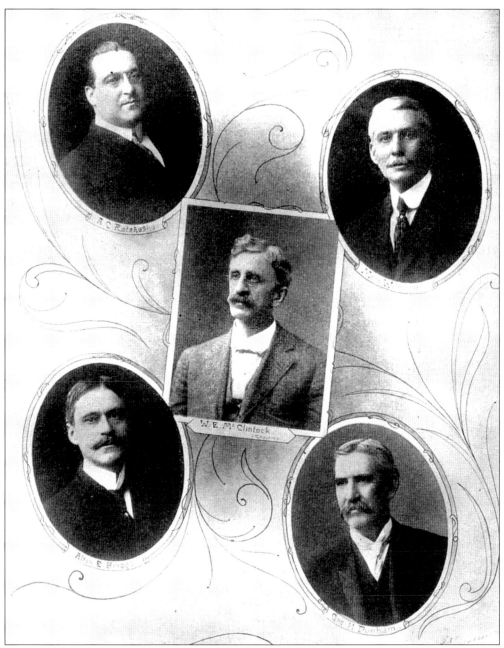

Facing the enormous task of rebuilding, the city decided to suspend its traditional government in favor of a board of control, specially created to deal with the challenges that lay ahead. The board was appointed by acting Massachusetts Gov. Eben Draper on June 3, 1908. It included William McClintock, the chairman, Abraham Ratshesky, Mark Wilmarth, Alton Briggs, and George Dunham. Meeting five days a week at the courthouse, these men had within six months returned all city departments to as near normal conditions as possible. They continued on the job for nearly five years, overseeing and making all the decisions required to put the city back on firm footing. (Courtesy of CPL.)

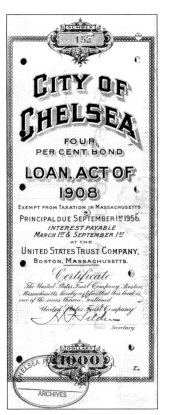

To cover expenses, the board voted to issue bonds in the amount of $400,000 at four percent interest, with the interest running for 50 years. This certificate indicates that the principal was due on September 1, 1956. Records at the Chelsea Public Library indicate that the debt was retired in 1960. (Courtesy of CPL.)

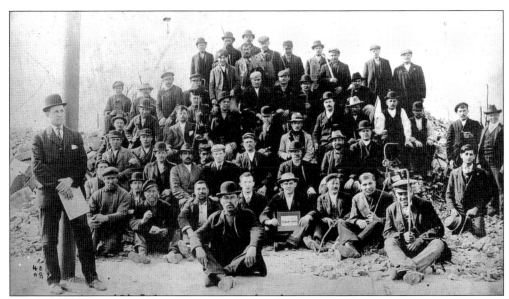

A group of men from the demolished Universalist Church, on Fourth Street, gathered with their picks and shovels to help with the enormous job of clearing the rubble. Eight churches and three synagogues were burned beyond repair. Most of them were rebuilt and are still in use today. (Courtesy of Robert Bayard Severy, family of William McClintock.)

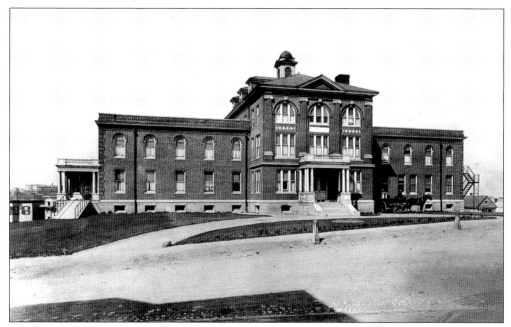

People depended greatly on their local hospital, and the new Frost Hospital on Bellingham Street was one of the first buildings completed. Hospitals were typically built on the top of a city's highest hill to take advantage of the fresh air. This was later renamed Chelsea Memorial and was the heartbeat of the city for much of the 20th century. Note the horse-drawn delivery wagon alongside the entrance. (Courtesy of Historic New England/The Society for the Preservation of New England Antiquities, hereinafter called HNE/SPNEA.)

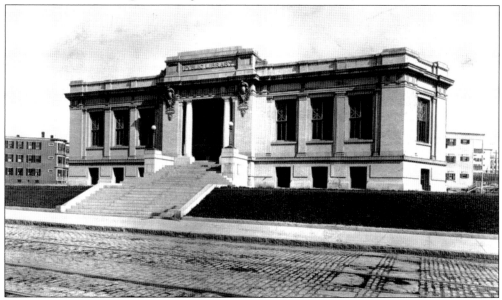

The Chelsea Public Library was built at a cost of $50,000 on the site of the earlier Fitz Library and was funded by philanthropist Andrew Carnegie. Designed by Guy Lowell, who also designed the Museum of Fine Arts in Boston, the library contains original furnishings and fine art, including Low tiles. This early photograph shows the rebuilding that was still in progress in the neighborhood, which had been entirely demolished. (Courtesy of HNE/SPNEA.)

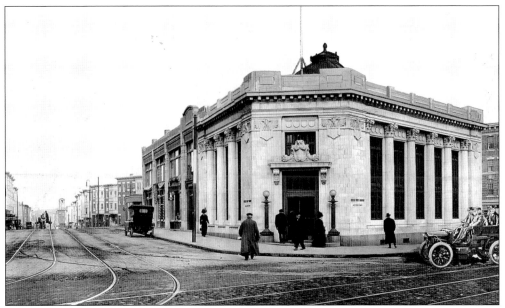

The Chelsea Trust Company erected a beautiful new building at the corner of Broadway and Everett Avenue. Similar to Quincy Market in Boston, there was a rotunda on the roof. Although many bankbooks had been lost in the fire, the management knew and trusted the depositors and extended them the cash they had in their accounts. Everett Avenue was rebuilt as far down as the railroad tracks. The automobiles have been inappropriately added to the scene. (Courtesy of HNE/SPNEA.)

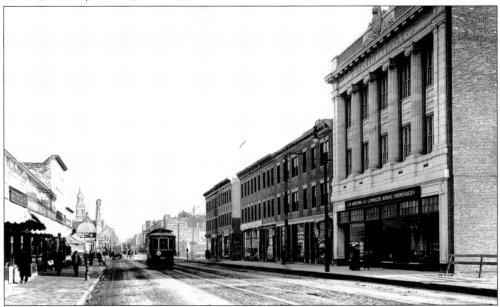

After much rebuilding, Broadway rose from the ashes. Always a favorite part of town, it was now more inviting than ever. With a handsome variety of new buildings, it served its citizens well, with everything from tea shops to vaudeville theaters. The steeple of the new Chelsea City Hall is in the left distance, and the elegant, white glazed terra-cotta Masonic Temple, at the right, remains the most beautiful building on the street. (Courtesy of HNE/SPNEA.)

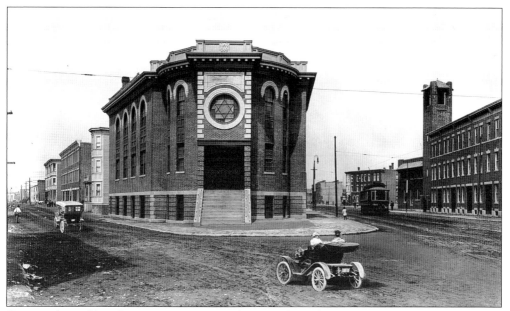

Organized in 1901, Congregation Avas Achim Ansha Ephard was the second-oldest Jewish congregation in the city. Its new building was constructed at the junction of Elm Street and Everett Avenue to replace the one that had burned. In 1912, another synagogue, Congregation Beth Hamidrash Hagodol was built on Third Street near the corner of Arlington. A third synagogue, Congregation Hagudath Shalom, the largest in the city, was built at Walnut and Fourth Streets. It is the only early synagogue that remains active today. The interior of the Elm Street synagogue is shown below. (Courtesy of HNE/SPNEA, and Joshua Resnek of the Chelsea Record, hereinafter called JR/CR.)

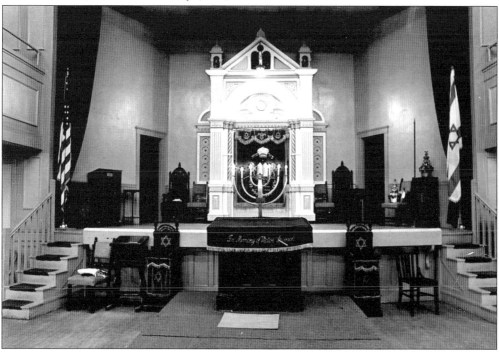

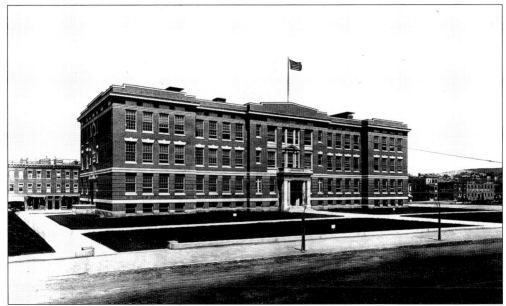

During the fire eight schools had been burned, and in order to serve the population in the city, they were a priority for rebuilding. The new Williams School was completed and dedicated on November 4, 1909. Speeches and a concert by the Boston Festival Orchestra marked the occasion. Notice the wide lawn in front and the newly constructed apartments in the background on Arlington Street. (Courtesy of HNE/SPNEA.)

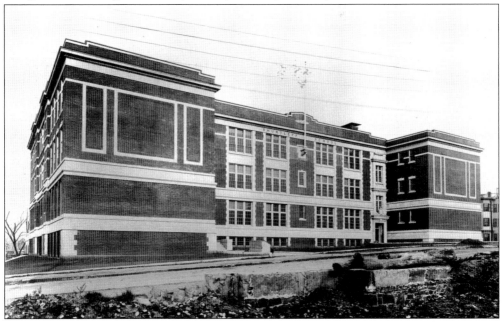

The new Shurtleff School was designed by Kilham & Hopkins, the same firm that designed Williams School. This 1910 photograph shows the Congress Street side of the building. Shurtleff also served a large student population, as it replaced four smaller schools in the Central Avenue section of the city. Notice the burned tree to the left and the debris from the fire that remains in the foreground. (Courtesy of HNE/SPNEA.)

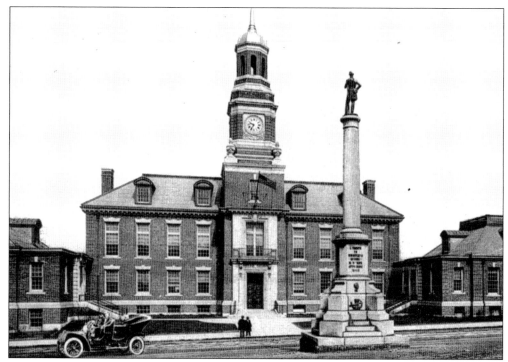

Peabody & Stearns of Boston was chosen to design the new Chelsea City Hall. Based on Independence Hall in Philadelphia, it is in the Georgian Revival style, built of common red brick, with terra-cotta trim, a green slate roof, and a gold-domed tower. Complete with furnishings, it cost $225,000. The furniture for the handsome new building was made at Holman Chair Company, located at 150 Marginal Street. (Author's collection.)

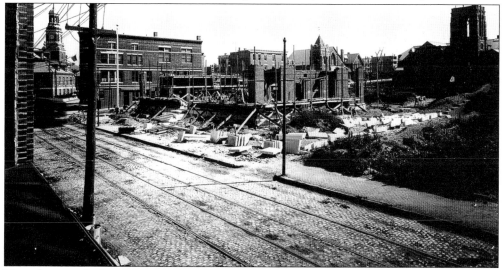

This photograph documents the building of the new post office in Bellingham Square. More centrally located than the old one in Chelsea Square, it was to be an architecturally significant building, with its Spanish Colonial Revival–inspired red tile roof, arched windows, and elaborate tile-and-brick frieze. Currently adapted for reuse by Bunker Hill Community College, it is an important mainstay of Bellingham Square. (Courtesy of CPL.)

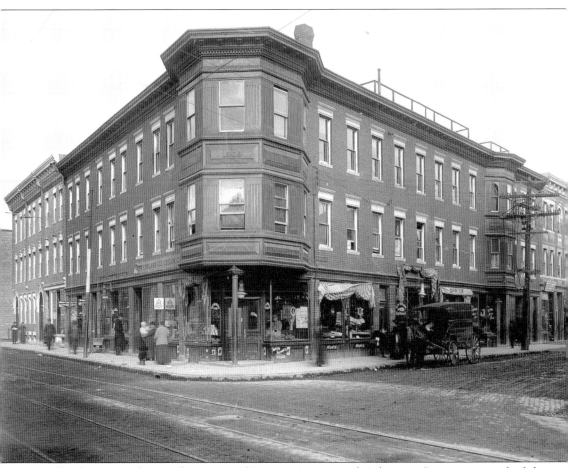

This large complex, at the corner of Everett Avenue and Arlington Street, is typical of the buildings constructed after the 1908 fire. It was city living at its most practical. The clean, new second- and third-floor apartments housed the maximum amount of people in the least amount of space, while the stores on the ground floor provided all the necessities of life for the urban population. At this time, people generally shopped daily for what they needed; one could buy a freshly killed chicken, bread just out of the oven, and fruits and vegetables only a day or two off the farm. Daily contact with one's neighbors was one of the most important aspects of city living. Although the neighborhoods were loosely divided along ethnic lines, there was much overlap, and most groups became familiar with and appreciated the various traits of their neighbors. The hustle and bustle of Everett Avenue and its surrounding streets was like a big city, yet it always had something of a small-town atmosphere. People were genuinely connected with one another, as they lived and worked together in the extraordinary melting pot that Chelsea became. Just a few of the buildings from this era remain along Everett Avenue, Walnut, and Arlington Streets. They are a significant connection with the city's past. (Courtesy of Bruce Lawson, hereinafter called BL.)

Two

A TRIP THROUGH TIME

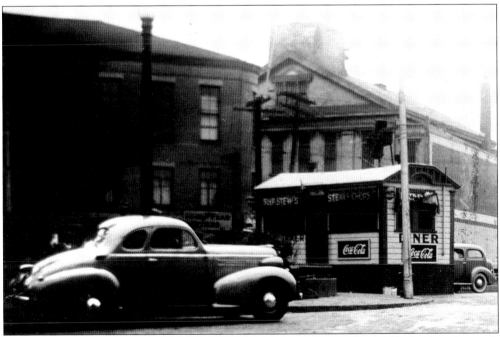

"Today, Chelsea is a live, bustling city, cosmopolitan in character and full of political, social, club, lodge, and religious activities. This season, for instance, Chelsea has quickly responded to the chance afforded by the organization of the Chelsea Club. This organization meets for luncheons at the YMCA every two weeks to hear speakers whose topics promote a spirit of good fellowship and good citizenship. The town is really enthusiastic over this new activity, which is making true city boosters." (Quote from James P. Heaton, Boston Chamber of Commerce, February 27, 1922.)

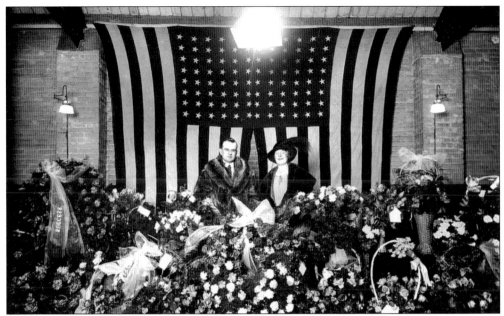

In 1922, Lawrence P. Quigley and his wife celebrated the first of his many terms as mayor of the city of Chelsea. Quigley set a record by being elected for five consecutive one-year terms, from 1922 to 1926, again in 1928, and lastly from 1932 to 1935. Wealthy old families were no longer the leaders in the new century; officeholders now were more likely to be first-generation Americans, especially Irish. (Courtesy of JR/CR.)

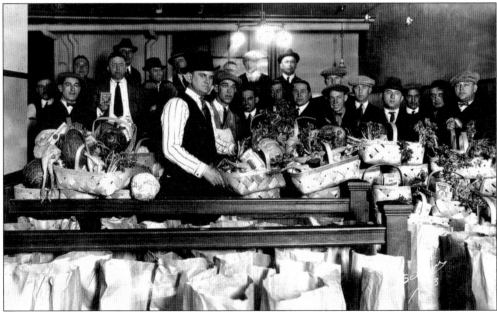

The mayor is seen here helping assemble baskets of food for families in need. What a welcome sight the baskets must have been. Traditional immigrant families often had a large number of children, which sometimes made a helping hand necessary. Although there was aid for widows with dependent children, there were none of the social service agencies as we know them today. (Courtesy of JR/CR.)

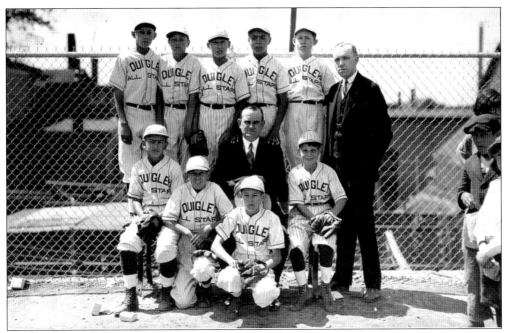

The Quigley All Stars baseball team assembles, with the mayor in the center. The privilege of showing up on the field in matching uniforms may have been the driving incentive to make the team. It certainly was a far cry from stickball in the streets or vacant lots. Lawrence P. Quigley was very involved in what was going on in the city. (Courtesy of JR/CR.)

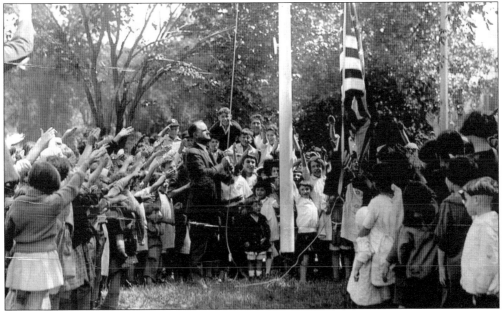

Raising the flag was another of the mayor's informal duties. Notice that the children are saluting the flag in the manner that was common in the 1920s and 1930s. Many of them were also likely first-generation Americans, and the Pledge of Allegiance was done with pride and enthusiasm. It appears that, for both boys and girls, simple haircuts were the order of the day. (Courtesy of CPL.)

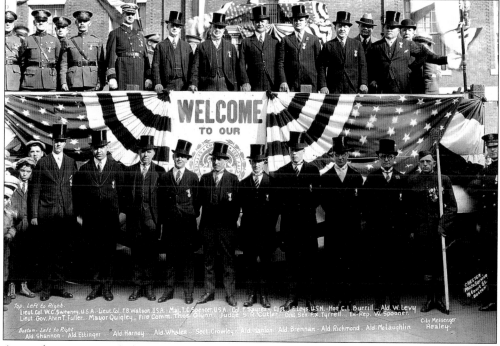

Top. Left to Right.
Lieut. Col. W.C. Sweeney, U.S.A. - Lieut. Col. F.B. Watson U.S.A. - Maj. T.C. Spencer, U.S.A. - Col. P. Sayres - Capt. J.F. Leys U.S.N. - Hon. C.L. Burrill... Ald. W. Levy
Lieut. Gov. Alvin T. Fuller... Mayor Quigley... Fire Comm. Thos. Glynn... Judge S.R. Cutler... Dist. Sen. F.X. Tyrrell... Ex-Rep. W. Spooner.
City Messenger Healey.
Bottom - Left to Right:
Ald. Shannon - Ald. Ettinger... Ald. Harney... Ald. Whalen... Sect. Crowley... Ald. Hanlon... Ald. Brennan - Ald. Richmond - Ald. McLaughlin

A proud moment in Chelsea's history came with the celebration of the 300th anniversary of its settlement in 1624. Pictured is the reviewing staff of the Tercentennial Parade, which passed in front of the Chelsea City Hall on May 31, 1924. Mayor Lawrence P. Quigley is fifth from the right in the top row. Note the early athletic shoes on the dapper young fellow crowding in at the left. (Courtesy of JR/CR.)

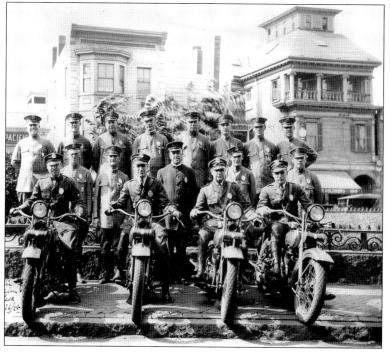

The Chelsea Police Department Motorcycle Traffic Division poses outside the courthouse on July 26, 1928. Behind the unit, along lower Broadway, is the cast-iron fence of Winnisimmet Park and a few local stores, including the Atlantic & Pacific, commonly known as the A & P. The buildings in the background still exist. (Courtesy of CPL.)

A newly rebuilt Broadway was also decked out in patriotic bunting to celebrate the city's 300th anniversary. At the right is the new home of the Chelsea Savings Bank, on the corner of Broadway and Congress Street. A modern facade covers the structure today. Notice the impressive early lighted sign for the electric company next-door. (Courtesy of Bruce Lawson and CPL.)

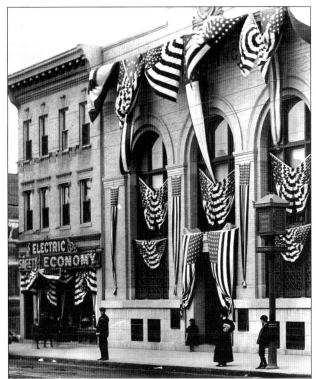

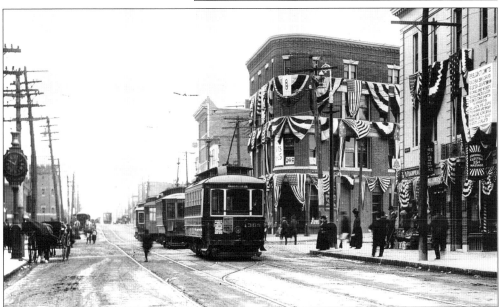

This view of Bellingham Square shows the considerable progress made in rebuilding since the fire. At the far left is the ever-present clock and the new armory. The former Chelsea Chamber of Commerce Building, now Margolis' Drug Store, is at the far right. The brick building at the corner of Bellingham Street was the Workmen's Circle Center, later home of the popular delicatessen Shapiro's Bell-Dell. It has been replaced by a modern bank building. (Courtesy of Bruce Lawson and CPL.)

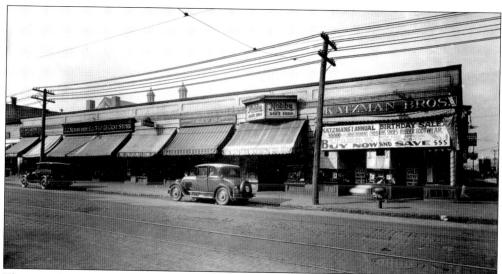

This wonderful image of Broadway near Fourth Street shows J. J. Newberry's, Chelsea's first five-and-ten-cent store. Next to it is the Chelsea Music Store, advertising Victrolas, which were hand-wound, nonelectric record players. St. Stanislaus Church is visible in the left distance behind the block of stores. The section at the corner is gone, but the rest of the block remains intact. (Courtesy of BL.)

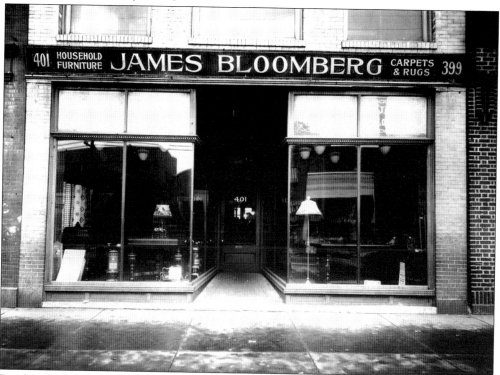

For decades, Bloomberg's was Chelsea's most popular furniture store. Hardly a home in the city did not have something that was purchased there. Bloomberg's later moved from this location to a much larger store at the corner of Broadway and Congress Avenue, and Promisel's Grocery took over this space. Somewhat altered, both buildings are still intact on Broadway. (Courtesy of BL.)

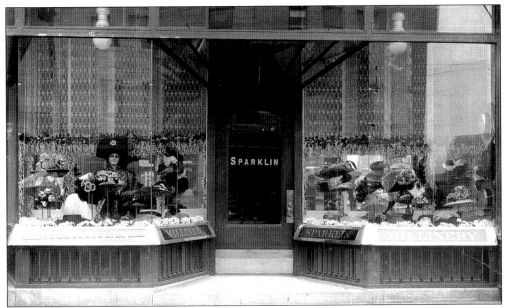

Just look at the incredible confections that women wore on their heads in the early 20th century. Creating one-of-a-kind hats was a real art at Sparklin Millinery, located at 356 Broadway. Broadway had a number of specialty shops, including furriers, dressmakers, and dairy stores. Before the rise of large department stores and supermarkets, individual shops catered to buyers with good taste and a generous pocketbook. (Courtesy of BL.)

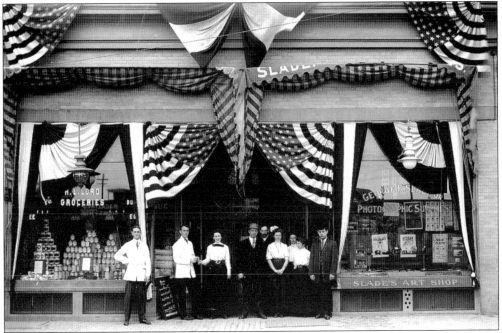

The dual storefronts of H. Lord Groceries and George F. Slade Jr. occupied 396 Broadway. Many of the photographs in this book are copies of originals that were taken by Slade. He deserves much credit for capturing moments from the past for us to enjoy today. His business continued on Broadway into the mid-20th century. (Courtesy of BL.)

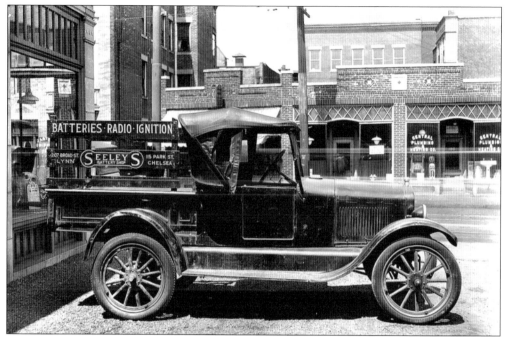

No matter what decade it is, it seems a man is proud of his truck—this one even has a convertible top. Chelsea has always had automobile connections; new cars, used cars, car parts, and even mounds of old rusted cars. Seeley's, on Park Street, helped keep the old cars going for as long as possible. (Courtesy of BL.)

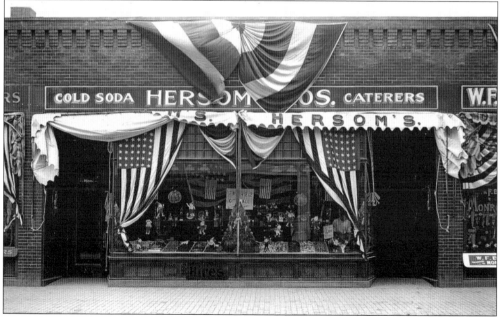

Now that you had the old car running, you might as well stop by Hersom's, on Broadway, for a lime rickey or a college ice. Then, perhaps you could take in a talking picture at the Strand, Olympia, or Broadway Theatre. You did not have to leave Chelsea to have a nice day or an evening's entertainment. (Courtesy of BL.)

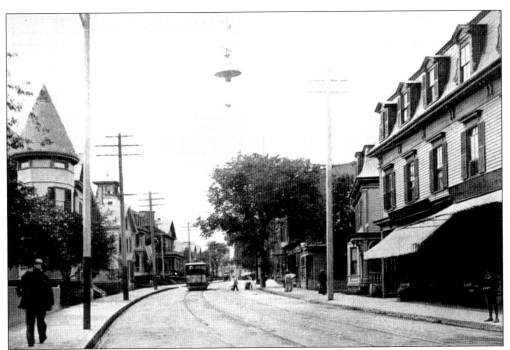

Stores were sprinkled every few blocks throughout the city, including the few here along Washington Avenue. With Bloomingdale Street just out of sight at the far right, the avenue looks much the same today. The Tudor Garage, a former livery stable at the far left, was upgraded to accommodate automobiles, which eventually replaced the old horse and carriage. (Author's collection.)

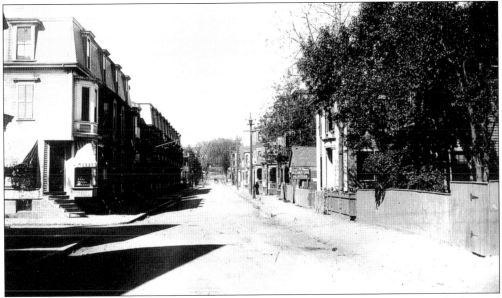

The warmth of a summer day is captured in this remarkable view at the corner of Eden and Bloomingdale Streets. Most of the buildings on the left have been replaced by a modern high rise, but many on the right remain. It makes one want travel back to 1910 just to be there. This, and the next three photographs are from the Slade Collection. (Courtesy of JR/CR.)

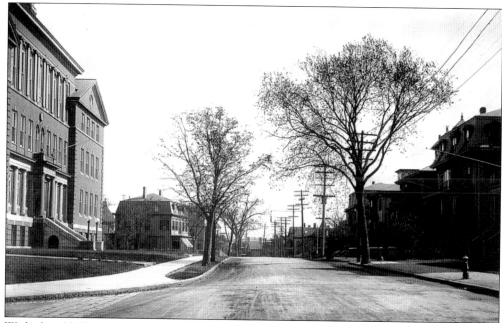

With the old Chelsea High School on the left, Crescent Avenue looks much the same today as it did when this photograph was taken 85 to 90 years ago. A few houses on the right have been replaced, but the granite wall remains in place, as solid as the day it was built. (Courtesy of JR/CR.)

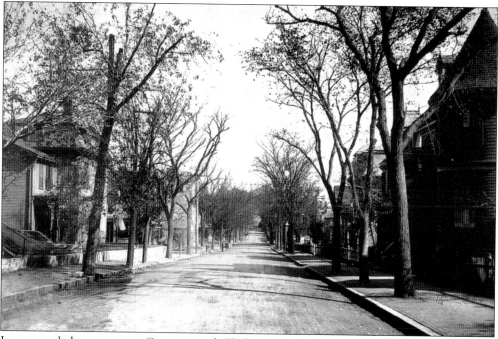

Just around the corner, at Crescent and Clark Avenues, more of this lovely neighborhood remains intact. The house at the right, with its rounded tower and gracious front porch, is similar to those on Bellingham Street and elsewhere in the fire district that were demolished. (Courtesy of JR/CR.)

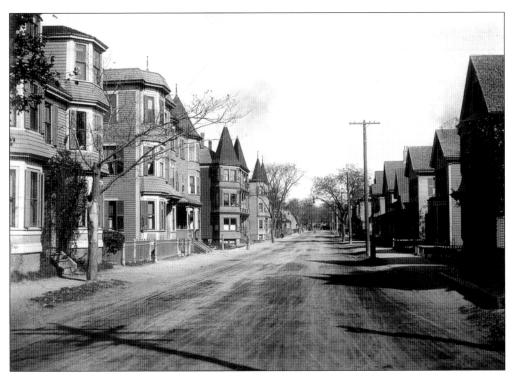

At the junction of Spencer and Crescent Avenues, Spencer Avenue has also managed to hold on to many of its early homes. Although some on the left are no longer there, the modest gable-end cottages on the right are still intact. The years before the arrival of the automobile appear to have been quiet ones indeed. (Courtesy of JR/CR.)

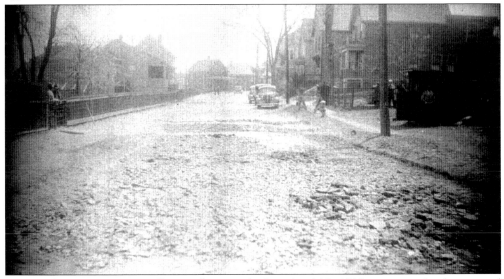

Springvale Avenue in Prattville was photographed on April 12, 1938, as it waited to be repaired and resurfaced. The little white house at the far end still stands on Washington Avenue. New homes filled in the empty lots during the 1950s, becoming the few modern houses in this old city. (Courtesy of Andy DeSantis of the Chelsea Department of Public Works, hereinafter called DPW.)

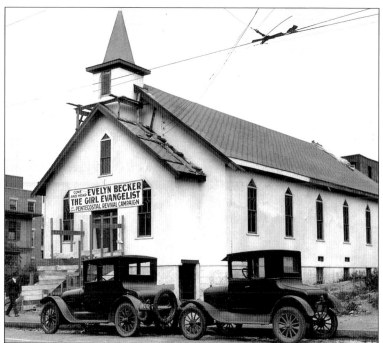

Traveling evangelist ministers were popular during the Roaring Twenties, as this 1926 photograph of the Pentecostal Church on Hawthorne Street indicates. With Prohibition creating problems of illegal consumption of alcohol, not to mention that new dance, the Charleston, there was plenty to be concerned about. The building is still there. (Courtesy of the BH.)

Originally built as a Congregational church in the 1840s, and still standing along Park Street in Chelsea Square in 1934, was the home of the Grand Army of the Republic (GAR). The *Boston Traveler* reported that the building would be going up for auction and the proceeds from the sale would be divided among the three remaining members of the association. Considering the building's age, there was a good deal of protest regarding its sale. It was eventually demolished. (Courtesy of the BH.)

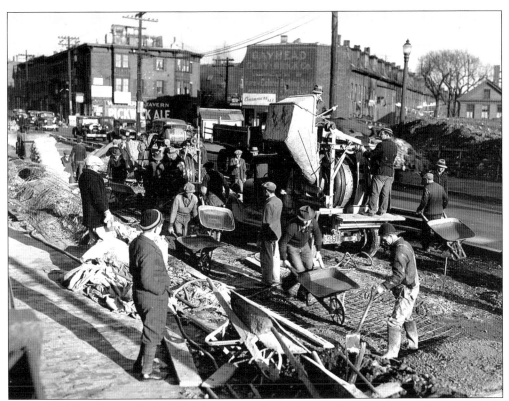

During the Great Depression, the Works Progress Administration (WPA) provided paying jobs for men who were unemployed. This hardworking crew is replacing bricks along the trolley tracks on lower Broadway. The brick row houses along Broadway and Medford Street are still intact. (Courtesy of JR/CR.)

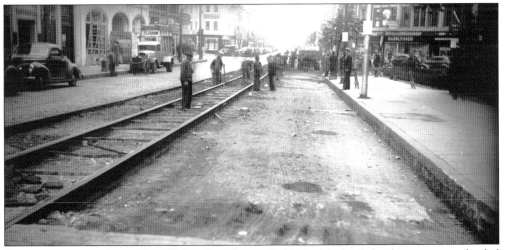

Street repairs were also made in Bellingham Square in 1940 with this federal government-funded program. On the left, construction of the Broadway National Bank is under way; note the three new arched windows being installed. The Chelsea Chamber of Commerce, at the junction of Hawthorne Street and Broadway, is near the center of the photograph, and Sanderson's Card Shop and Tony's Spa are at the right. (Courtesy of the DPW.)

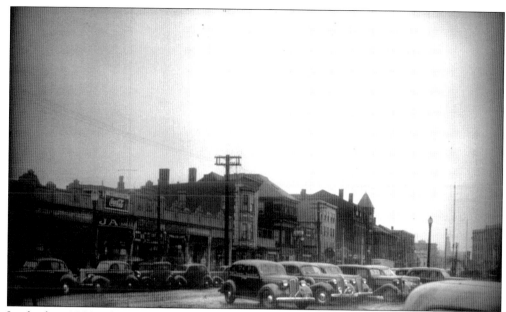

In the late 1930s, there was a good deal of concern about the traffic congestion in Chelsea Square, and various alternatives were discussed to solve the parking problem. Suggestions included moving the monuments to other parts of the city. This view of the square shows the continued popularity of this older part of the city. (Courtesy of the DPW.)

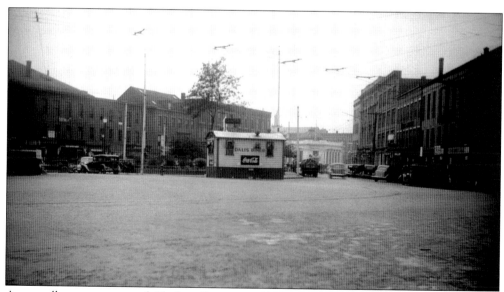

An excellent panorama of Chelsea Square in 1938, this view includes 19th-century brick commercial buildings on the left, some of which still stand, the Chelsea Trust Company at Everett Avenue, and the refurbished Elks Hall and Gerrish Block on the right. The popular Dalis' Diner, in the center, is a colorful reminder of the past. (Courtesy of the DPW.)

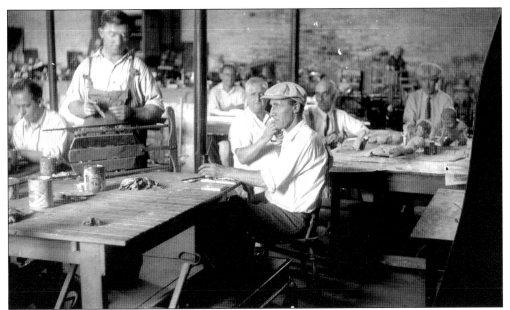

Repairing toys for children became another WPA project, possibly for men who could not do heavy labor or had woodworking skills. A workspace was set up in the basement of Prattville School, and men were employed to clean, repair, and paint worn-out toys for reuse by needy families. (Courtesy of the DPW.)

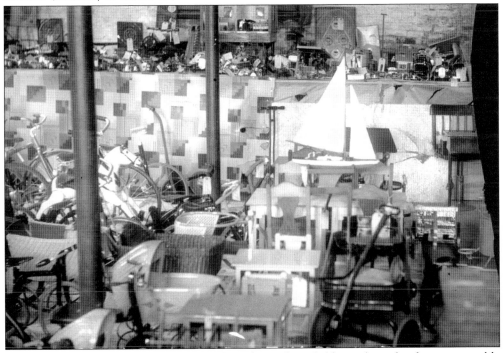

The toys were stored at the school and then donated to children whose families were unable to afford to buy new ones at Christmas. What a wonderful collection—games, wagons, sleds, bicycles, and doll buggies—it might have been the best Christmas some children ever had. (Courtesy of the DPW.)

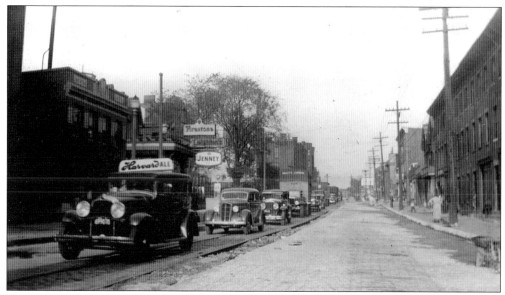

Cars and trucks are lined up along lower Broadway, waiting to cross the old Chelsea Bridge to Charlestown. The swing bridge caused numerous delays and long backups in and out of the city. The homes and commercial buildings on the left and right remain there to this day. The Polish Political Club currently occupies a brick building at the far left, just out of the frame of this photograph. (Courtesy of JR/CR.)

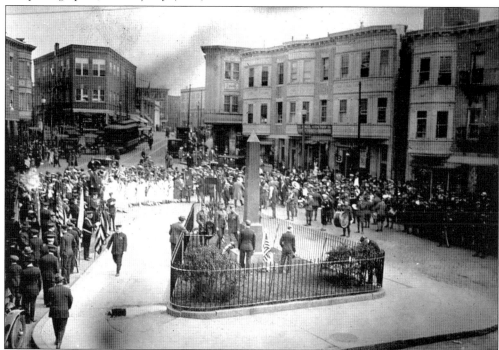

In 1935, a small island on Everett Avenue and Third Street was dedicated as a memorial to Max Address, the first Jewish soldier from Chelsea to be killed in World War I. It was later removed to make way for the construction of the Mystic River Bridge, in 1949. The obelisk now stands outside the Chelsea City Hall. (Courtesy of CPL.)

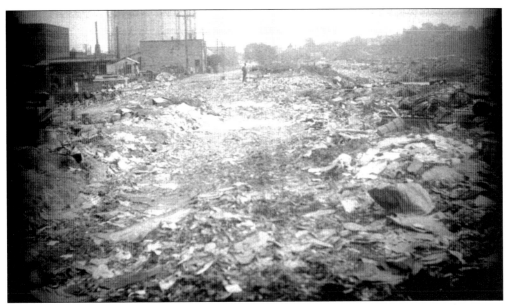

A number of dumps around the city created a dangerous and unpleasant nuisance. The one in this photograph was on Williams Street. The clay pit, site of a former brickworks off of Webster Avenue, was another of the longstanding and worst offenders. (Courtesy of DPW.)

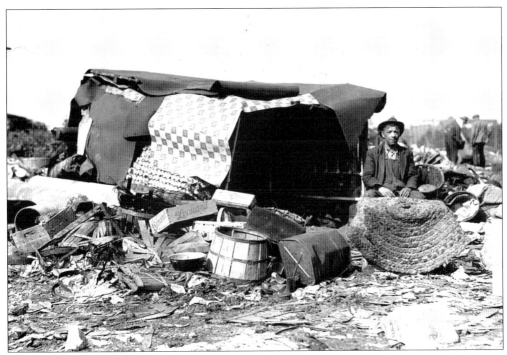

Unfortunately for some in the 1930s, the dump was home. This poor fellow has made the best of things by constructing a shelter from an old iron bedstead, tarpaper, and linoleum. Hopefully, the publication of this photograph in the *Boston Advertiser* brought aid to him and others in this situation. (Courtesy of the BH.)

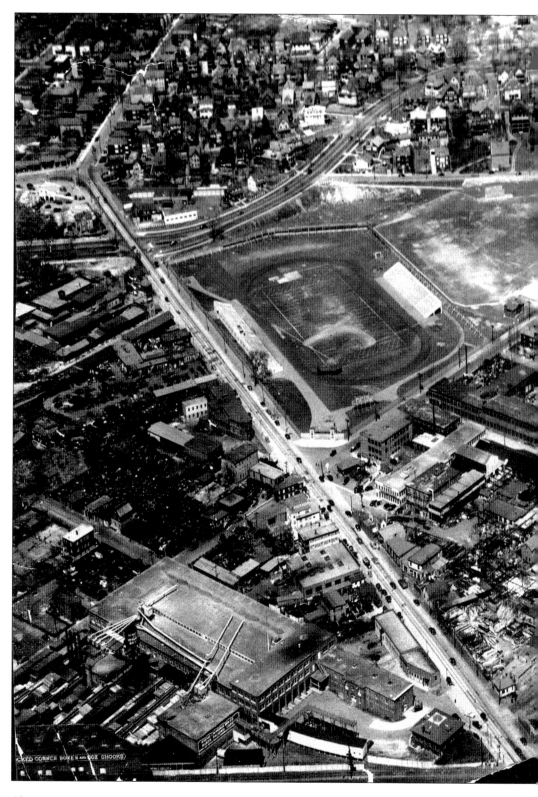

This panorama, taken in 1941, covers Everett Avenue from the railroad tracks to the Revere Beach Parkway. The factories, lumberyards, and assorted salvage dealers appear in the lower portion of the photograph, and the residential areas are off to the north and east. In the center is the Chelsea Memorial Stadium, built in 1935, with the Carter Street playground to its right. At present, the new high school sits in half of the old stadium, and the expressway has encroached upon many of the surrounding streets. Familiar places to look for are the Strahan Wallpaper Company, the First Congregational Church, on County Road, and the Quigley Apartments, on Washington Avenue. (Courtesy of BH.)

Aside from some alterations, most of the homes pictured along Washington Avenue and County Road in 1943 look much the same today. Buses had replaced the trolleys, and it was still a quiet part of town. Traffic through the area has increased a great deal since that time, along with the changes created by the expressway. (Courtesy of HNE/SPNEA.)

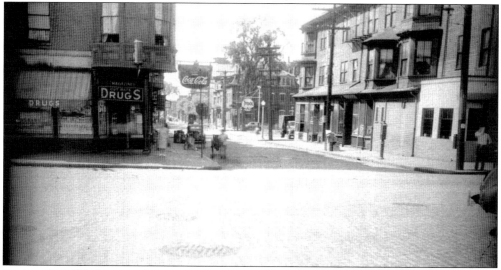

Farther along Washington Avenue, at the corner of Sagamore, is a collection of stores that some may recognize in this mid-1930s photograph. The drugstore at the corner has been significantly altered and is now a restaurant. The large building at the right has given way to a parking lot, and the gas station no longer exists. (Courtesy of DPW.)

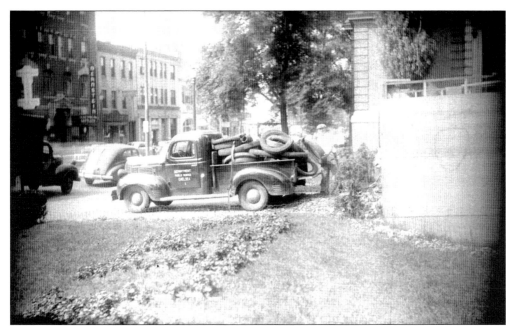

During the years of World War II, people bought war bonds and endured the rationing of food, clothing, and gasoline. An effort that seemed to bring out the patriotism in everyone was the collection of salvaged materials, which were recycled into military products. This photograph was taken on July 2, 1942, just before the city's Fourth of July celebration. (Courtesy of DPW.)

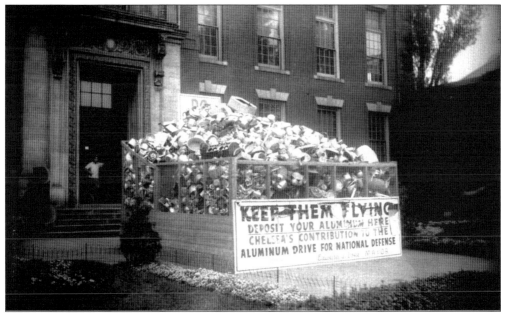

"Keep Them Flying"—how could one resist that wonderful slogan? Although aluminum was not particularly plentiful, folks filled this huge container outside the Chelsea City Hall with all kinds of aluminum scrap that could be recycled for use in airplane manufacture. (Courtesy of DPW.)

City of Chelsea

Recognition of Patriotic Service

LIBERTY · DEMOCRACY · JUSTICE

is hereby given to

Vincent P. Jarmulowicz

by the people of Chelsea as a symbol of their gratitude for his
loyalty and patriotism in the service of the armed forces of
the United States in the greatest struggle in world history.

For the Cause of Freedom

Approved by the
Board of Aldermen
1942

MAYOR

In August 1942, a plaque was designed and presented to the parents of each of the "Chelsea Boys," as they were called, who were serving in the armed forces during World War II. Below, a state guard unit marches down Everett Avenue in the parade that preceded the exercises held at the Chelsea Memorial Stadium. The original stadium, now demolished, was built in 1935 to honor the men and women who had lost their lives in World War I. (Courtesy of DPW and BH.)

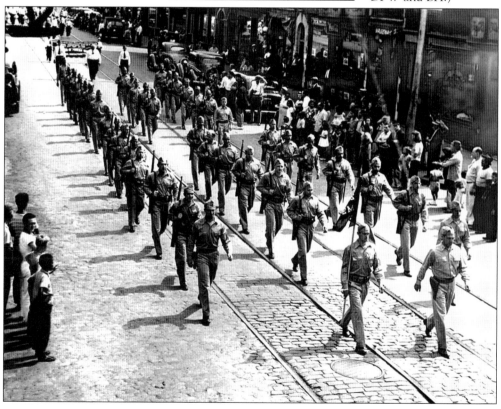

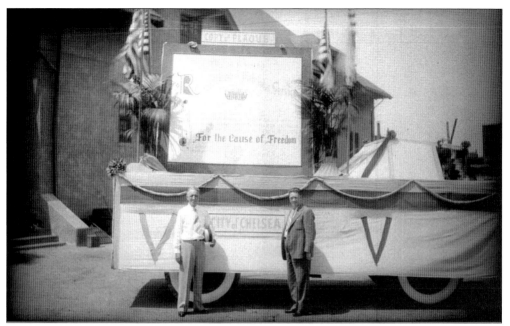

As part of the Chelsea Plaque Parade, floats were decorated by various city departments and local organizations in honor of the military. Above are Mayor Bernard Sullivan, on the right, and City Engineer O'Brien at the city stables with a large depiction of the plaque. Below, the Chelsea Lodge of Elks float pays tribute to the city's men and women serving both here and abroad. (Courtesy of DPW.)

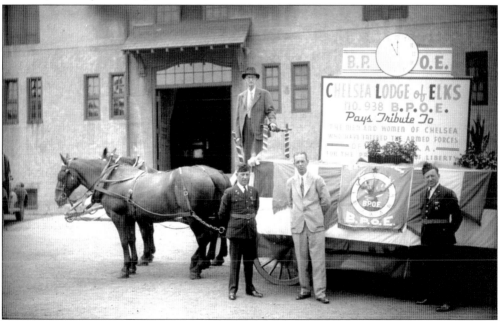

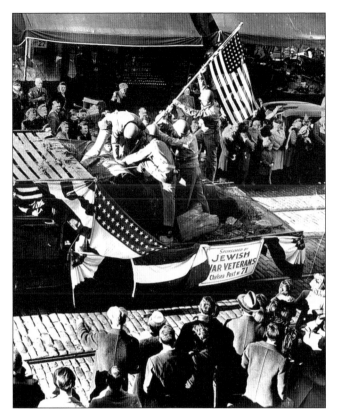

In 1945, at the end of World War II, a Victory Day Parade was held in the city. As citizens gathered along Broadway, a float commemorating the raising of the American flag at Iwo Jima, sponsored by the Jewish War Veterans, passes by. It was a proud day for all. (Ostroff photograph, courtesy of BH.)

In January 1947, a war memorial was dedicated at Chelsea High School, on Crescent Avenue. It read, "In Memory of our Brave Boys who made the Supreme Sacrifice for our Country in World War II." At the head of the stairs as one enters the building, the bronze plaque, surrounded by a hand-painted mural, remains a beautiful and fitting tribute. Admiring it are Mayor Bernard Sullivan, on the left; Henrietta Greenglass, chairman of the Chelsea School Committee; and Julius Alpert, chairman of the Memorial Committee. (Courtesy of BH.)

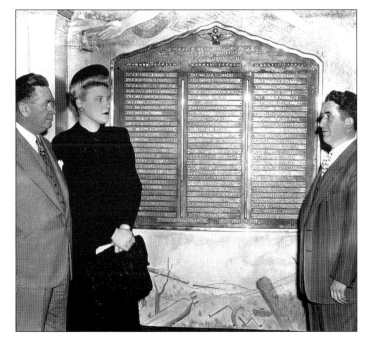

After the war, every day became special, as young soldiers returned to enjoy the simple pleasures that the old hometown offered—perhaps a nice, cool Coke at Sokol's, on Broadway and Second Street, with friends, followed by the annual Chelsea-Everett Football Dance, hopefully to celebrate the high school's win at the all-important Thanksgiving Day game. Life was good again. (Courtesy of CM and DPW.)

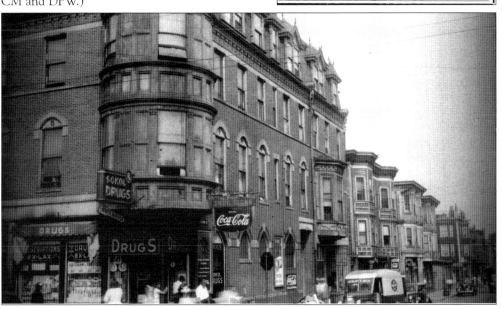

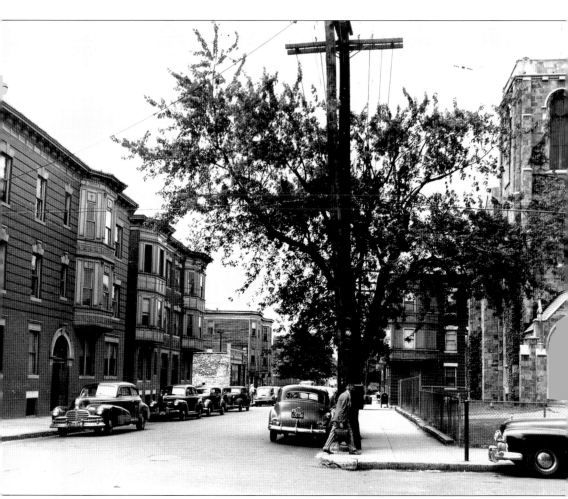

This rather idyllic scene on Fifth and Chestnut Streets was captured in June 1949. Newer model cars have replaced the old automobiles. The trees lost in the fire have grown back. The Salvation Army has settled into the modest little stone church at the corner, formerly the Central Congregational, to do its good deeds. The city had survived the 1908 fire, the Roaring Twenties, the Great Depression, and the sacrifices made during World War II. The 1950s were about to explode upon the city. The baby boom, the promise of prosperity, the Mystic River Bridge, and the time of the teenager were on the horizon. (Courtesy of Massport, hereinafter called MP.)

Three

ON THE WATERFRONT

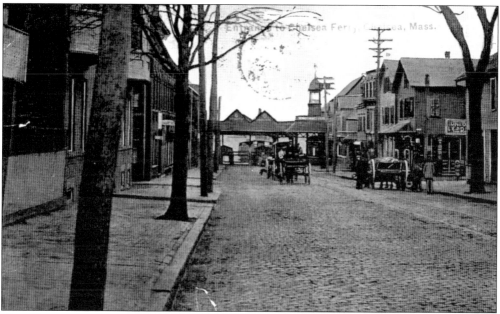

The Winnisimmet Ferry was the first commercial attempt to connect Chelsea with Boston, located just a mile across the Mystic River. The ferry survived until 1917, nearly 300 years after it began. Trips aboard the ferry were fondly remembered by former resident Charles N. Morgan, who reminisced in 1939 about the $2^1/2$¢ fare, compared with 5¢ to take the new trolley car over the Chelsea Bridge. "Occasionally, one got much more than a short ride for his $2^1/2$ cents. Once, a sudden, heavy fog bewildered the pilot and after an hour's sail, the passengers descried the South Boston shore. The biggest adventure in the ferry's later history was that of passengers aboard the boat that sank, perhaps through sheer weariness from over-long service. The pilot swung her over to the mud flats near the Meridian Street bridge and there she squatted, with her upper decks far enough above water safely to accommodate excited, indignant, frightened passengers." (Author's collection.)

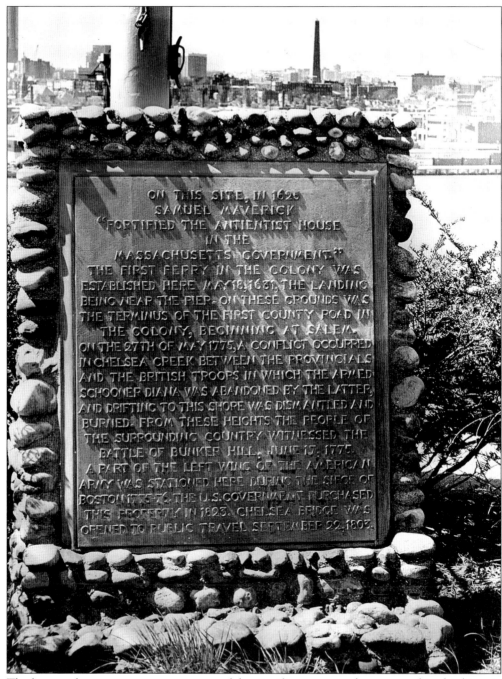

The bronze plaque commemorates many of the significant events that occurred in this historic area, including the site of the first ferry, in 1631; the location of the first county road in the colony, which began in Salem; the place where, in May 1775, the Revolutionary conflict known as the Battle of Chelsea Creek was fought; the viewing spot for the June 1775 Battle of Bunker Hill, across the water in Charlestown; and the opening of the first Chelsea Bridge, in 1803. The whereabouts of this important historical marker is currently unknown. (Courtesy of Harry Zeltsar, JR/CR.)

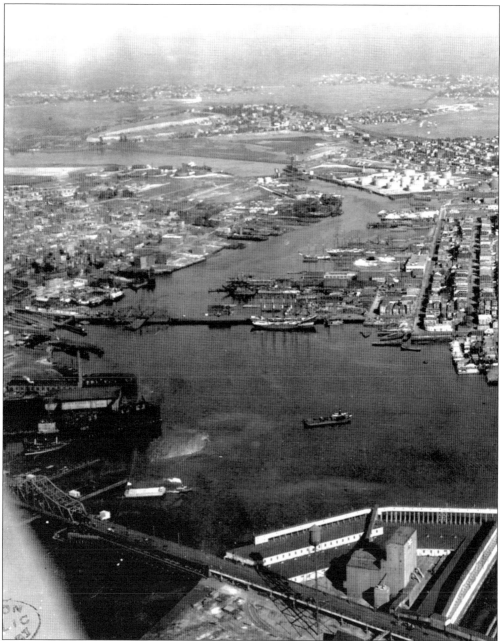

This 1925 aerial view shows the waterfront of Chelsea, Charlestown, and East Boston. At the lower left, the old Chelsea Bridge crosses the Mystic River to Charlestown. Farther up the coastline, along Marginal Street, is the powerhouse, the old ferry slip, shipyards, and the Boston Rubber Company. Beyond the Meridien Street Bridge to East Boston, one could find lumberyards, a coal company, and a box factory. In the Highland and Willow Streets area was the shipyard of Richard T. Green and the buildings that housed paint manufacturer Samuel Cabot. Around the bend of Chelsea Creek, along Eastern Avenue, were the huge complexes of the Revere Rubber Company and Forbes Lithograph Company. Thousands of Chelsea residents found employment in these important industries over the years. (Courtesy of BPL.)

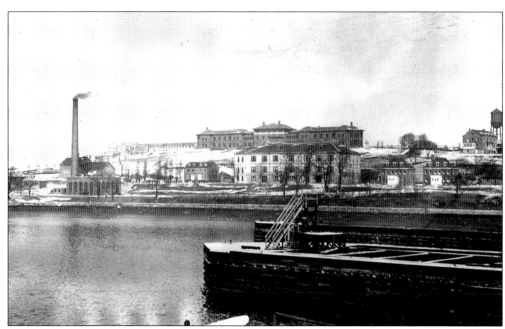

A quiet winter day in February 1930 finds a layer of new snow covering the grass on Naval Hospital Hill and the docks on the Charlestown side of the Mystic River. It was between the wars, and one almost senses the beginning of the hard decade of the Great Depression, which lay ahead. In contrast, below, prosperous times find pleasure boats and commercial vessels filling the busy waterfront on a warm, sunny day, with Boston's 1916 Custom House Tower in the distance. (Courtesy of BH and JR/CR.)

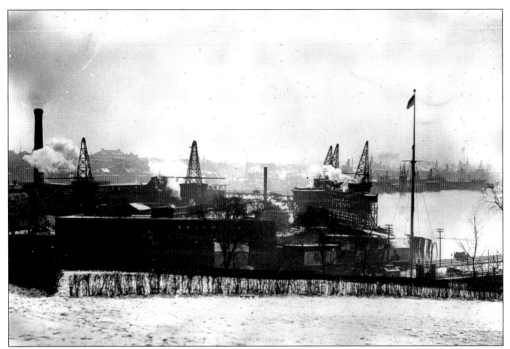

The power plant and the coal yards needed to keep it going were located along the foot of Broadway. In this view from the hill on the Naval Hospital grounds, the old Chelsea Bridge to Charlestown is at the right. There was little understanding about the environment in the 1920s, and the air must have been thick with soot and smoke. As industry arrived, the mid-19th-century house below, which still survives on Front Street, lost its pristine view of the waterfront. (Courtesy of BH and JR/CR)

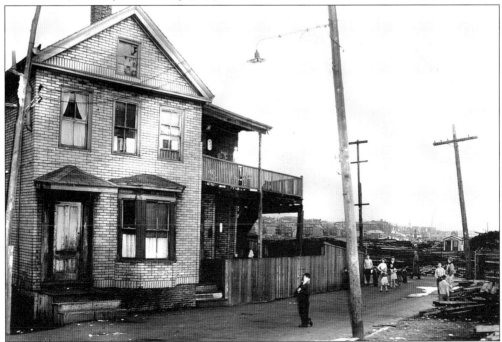

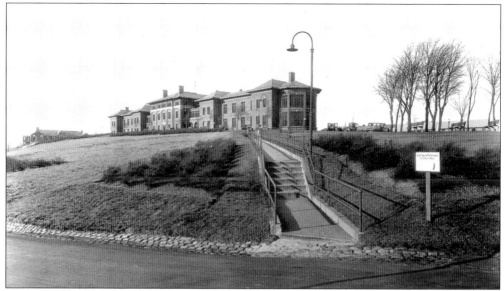

In 1915, the government began more development of the site it had owned since the early 19th century. A new brick Naval Hospital was built to supplement the earlier buildings, which were constructed in the 1820s, 1830s, and 1860s. Over the years, the complex grew to serve the increasing needs of military families. The hospital was decommissioned in 1974 and demolished shortly thereafter, removing a significant landmark from the city's skyline. (Courtesy of BH.)

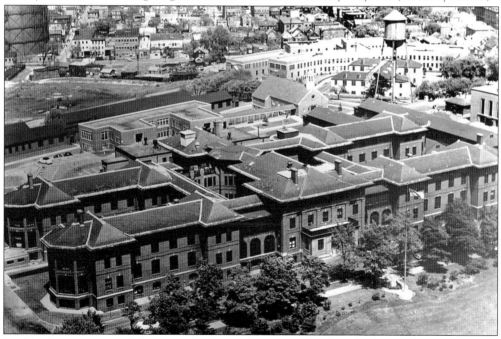

In this view are some of the many buildings that were added to the hospital site during the 20th century. It was a city unto itself. The wounded from World War II, the Korean Conflict, and the Vietnam War were cared for here. In 1960, more than 8,000 military personnel and their families were admitted to the hospital. Outpatients totaled over 82,000 during that year. (Courtesy of BH.)

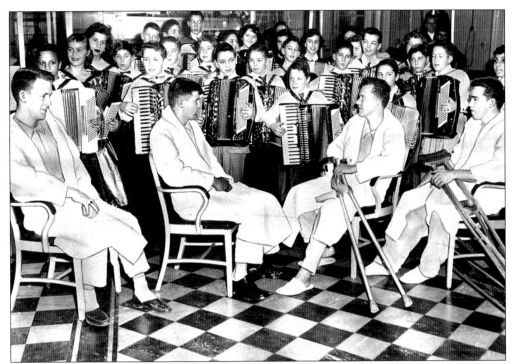

Hospitalized during the 1943 Christmas season, these recuperating soldiers were treated to a concert by students from the Hollis Music Studio of Boston. The musicians strolled through the wards, playing Christmas carols on their accordions. There appeared to be great emphasis placed on entertaining the wounded men. (Courtesy of BH.)

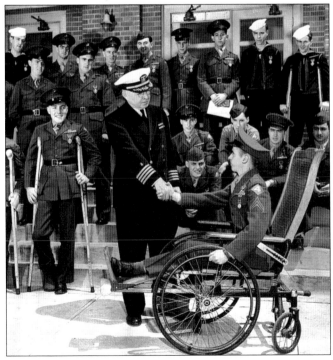

These young World War II military personnel at the Naval Hospital were still convalescing from their wounds as Capt. Frederick Conklin awarded them Purple Hearts for bravery. The hospital was considered a superb medical facility, and Boston hospitals often sent their instructors and students there to learn the latest in medical treatments. (Courtesy of BH.)

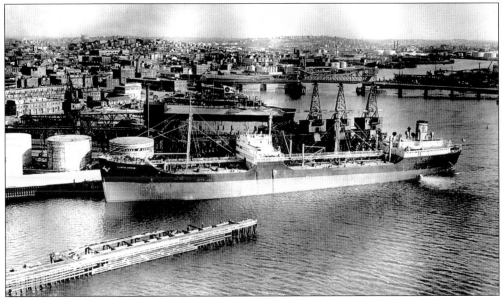

Chelsea has been involved in the shipbuilding and repair industry since the 1830s. In the 19th century, clipper ships with names like *George Washington* and *Storm King* sailed out into the harbor, bound for the riches of China. This photograph offers a great view of the city, from its busy waterfront to the densely populated neighborhoods that surround it. (Courtesy of JR/CR.)

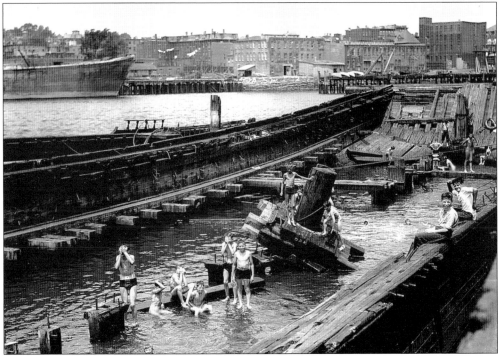

Local boys splash about in the waters between Chelsea and East Boston in 1935, most likely having taken a day off from school. The all-but-sunken ship appears to be an old lumber scow. Numerous firsthand accounts tell of the freedom children were given to mill around the busy shipyards, playing or picking up odd jobs. (Courtesy of BPL.)

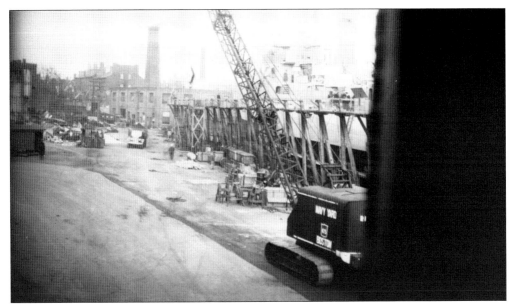

A 1920 newspaper headlined, "New Chelsea Drydock Open. Huge Marine Railway." The article referred to the "monster new marine railway" of Richard T. Green on Winnisimmet and Pearl Streets. From its beginnings in East Boston in 1853, the business was now the largest dry dock north of New York. (Courtesy of DPW.)

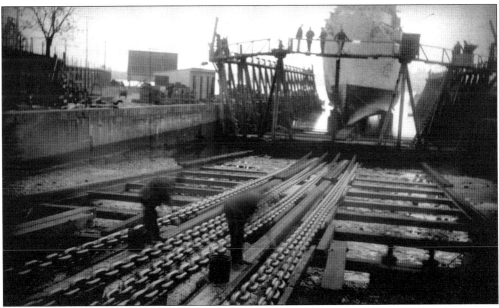

Prior to World War I, ships were normally dry-docked at Newport News or Norfolk, Virginia, once a year to have their bottoms inspected, scrubbed, and painted. After that time, they were brought into the nearest available facility that could accommodate their size, R. T. Green in Chelsea being one of them. (Courtesy of DPW.)

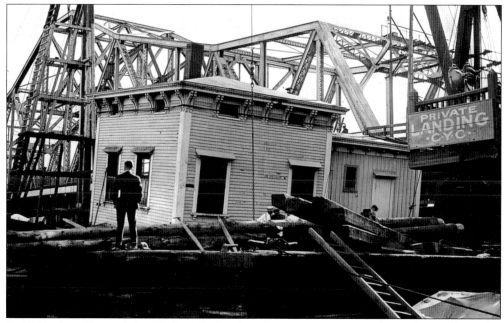

In 1934, the pilings of the Chelsea Bridge draw house gave way, nearly sending it down the Mystic River. Fortunately, the three men inside were able to get out safely. The old pilings, installed *c.* 1860, were replaced, and the building survived another 16 years until the erection of the Mystic River Bridge put an end to its usefulness. (Courtesy of BH.)

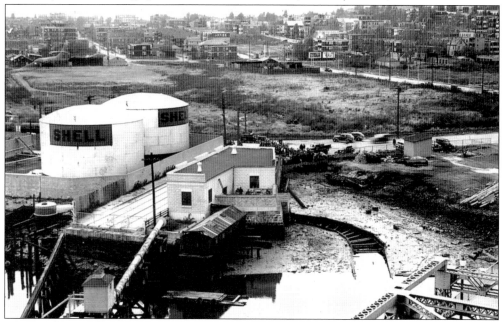

In 1937, this was the site of another accident in which two men were swept away while working in a manhole upstream. Diving operations were organized to recover them at the Metropolitan District Commission (MDC) sewage station near the bridge to East Boston. Central Avenue runs along the right, with Bellingham hill behind it. A very scruffy Highland Park covers the middle of the scene. (Courtesy of BH.)

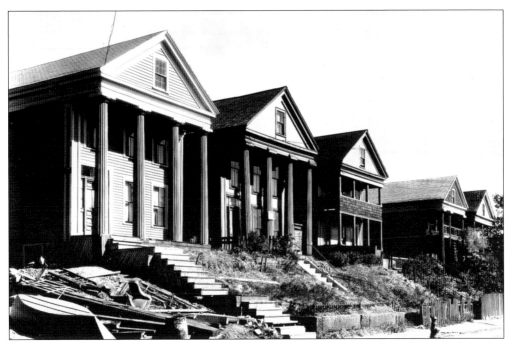

In the 1930s, five of the legendary Captain's Houses on Marginal Street still survived. Today, only the first, third, and fourth exist. When built in 1840, they commanded a spectacular view of the harbor and the city of Boston. As industry took over on Marginal Street, their location became less desirable. The one at left has been carefully restored, an elegant reminder of Chelsea's past. (Courtesy of HNE/SPNEA.)

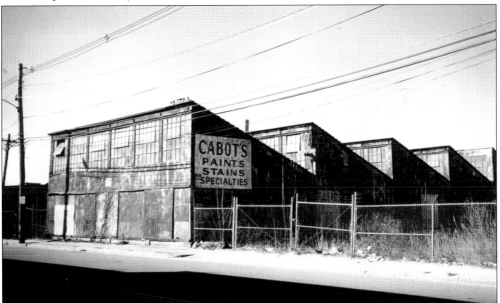

Near the end of Marginal Street, mimicking the row of homes above, stand some of the buildings that remain from Samuel Cabot's huge paint factory complex. The weathered, rusted metal is a less elegant but nevertheless important reminder of the city's industrial history. (Author's collection.)

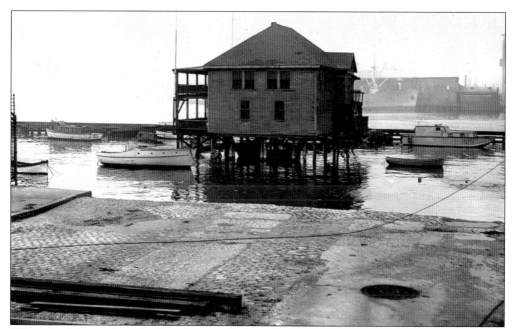

When the Mystic River Bridge was completed in 1950, the earlier drawbridge at the site was demolished. Unfortunately, this meant that there was no longer a way to get to the Chelsea Yacht Club by land. The club, which was chartered in 1836, sued for damages in superior court but lost the case. The early-20th-century building was left high and dry until a new dock was built. With more than 100 members, and a waiting list to join, the yacht club is still quite popular. (Courtesy of BH.)

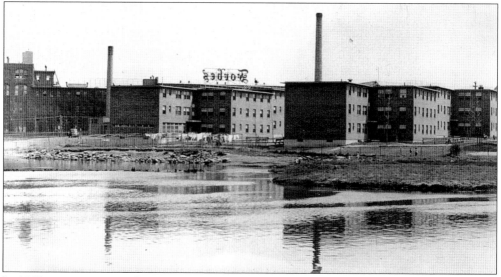

In 1952, a new veterans' housing project was built on Clinton Street, at the very edge of the city, along Chelsea Creek. The loss of homes due to the construction of the Mystic River Bridge, along with the baby boom that followed the end of World War II, created a critical need in the city for additional affordable housing. Note the Forbes sign on the main building; if you were employed at Forbes Lithograph Company, you had just a short walk to work. (Courtesy of JR/CR.)

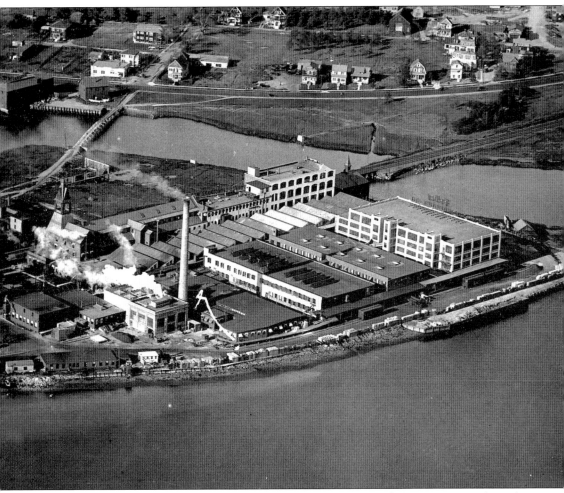

Forbes Lithograph Company, established in Boston in 1862, covered 500,000 square feet of land at the water's edge. Among the company's early products were decorative labels for bolts of fabric. After moving to Chelsea in 1884, Forbes became a leader in multicolored packaging and advertising materials. During World War I, its artists designed beautiful and patriotic recruiting posters, as well as sheet music for popular songs. In the 1940s, Forbes produced maps of Europe that were used for military purposes, as well as currency for servicemen stationed overseas and books for their children here at home. Employing more than 600 employees in the 1950s, Forbes was a leader in the field of advertising for over 100 years. The billboard posters in the upper left near the roadway are more of the company's artistic creations. The road along the top is the Revere Beach Parkway. Notice that there was also a connecting road between the parkway and the Forbes complex, just past the old Slade's Mill. (Courtesy of BPL.)

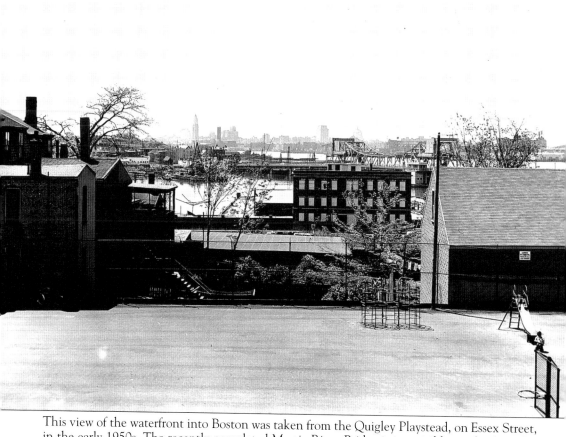

This view of the waterfront into Boston was taken from the Quigley Playstead, on Essex Street, in the early 1950s. The recently completed Mystic River Bridge is just visible on the far right, with the Meridien Street bridge in the right center. What a remarkably unobstructed view of the Boston skyline. Not many years after this photograph was taken, Boston began to add more and more tall buildings, altering the skyline dramatically. At this time, the two tallest buildings were the 1916 Custom House Tower, in the left center, and the 1949 John Hancock Insurance Company building on Berkeley Street, in the right center. On the Chelsea side, Shurtleff Street, whose 1870s homes retain their delightful mansard roofs, is on the left. Fortunately, these houses escaped the 1908 fire, which cut through the middle of Essex Street, sparing one side and burning the other to the ground. (Courtesy of JR/CR.)

Four

PLAY BALL!

On January 12, 1935, former Mayor John Beck, editor of the *Chelsea Gazette*, wrote, "The splendid work accomplished by the Park Commission in improving Merritt Park recalls to mind that sterling character to whom all credit should be given for securing the land for the purpose of the park. Nineteen years will have passed since Marcus M. Merritt died on January 16, 1916, one of Chelsea's most public spirited citizens. We sometimes forget these things and fail to remember those men of the past who have done so much for our city. It was through his indefatigable efforts that we now have Merritt Park." Merritt was a prominent tobacconist, who at one time had three stores on Broadway. His best-known store was in Chelsea Square, where "Lo" the American Indian stood out front. Once a figurehead on a U.S. warship, the life-size statue now stands in the Gov. Bellingham-Cary House, on Parker Street. (Courtesy of CPL.)

The "Everett Grounds," as they were called, along Carter Street and Everett Avenue, were in rather deplorable condition when they were photographed in 1934. Surrounded by various factories and salvage yards, the area had been neglected over time. Some of the buildings in this view remain today, including those of the Atwood & McManus Box Factory, just left of center, which later became A. L. Smith Iron and then Smithcraft Lighting. (Courtesy of CPL.)

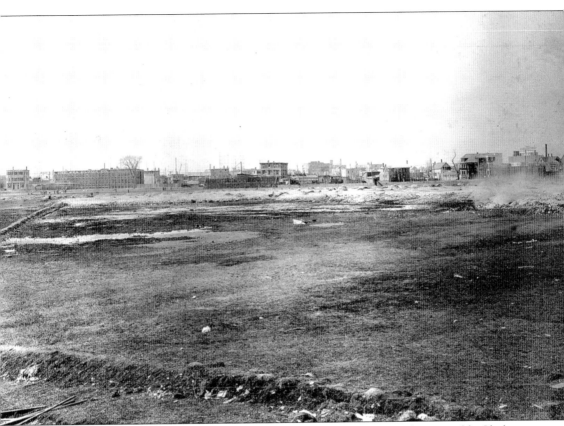

This is the same site, just to the right of the view on the previous page. The venerable Chelsea Clock Company, at this location since the late 19th century, is at the left. There is a set of bleachers in the area, but with a pile of trash smoking along the parkway, it is hard to imagine any spectator sports being played in such a space. Fortunately, Mayor Lawrence P. Quigley had long wanted a stadium, and work on one began shortly after these photographs were taken. (Courtesy of CPL.)

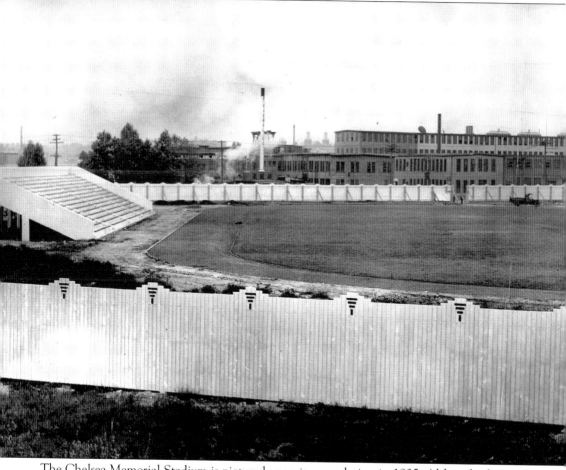

The Chelsea Memorial Stadium is pictured upon its completion in 1935. Although plans were drawn for the stadium during the 1920s, construction did not begin until some years later. There was strong sentiment to memorialize the sacrifice made by local men and women who had died in what was then called the Great War. The Chelsea Cement Company, on Everett

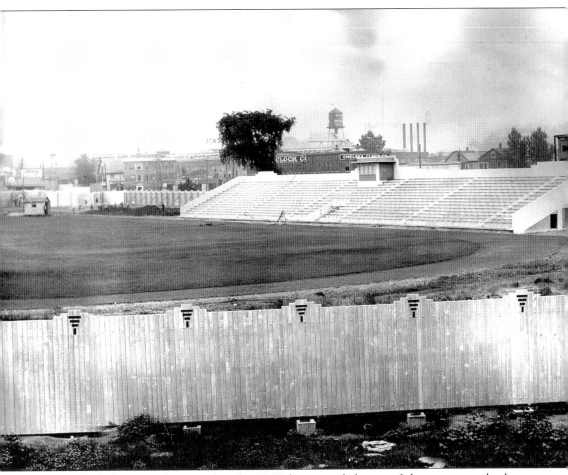

Avenue, which began in the city after the 1908 fire, provided most of the cement and other supplies used in the construction of this $150,000 memorial. The white painted fence is a modest version of the popular Art Deco style, with its geometric stepped feature at the top of the fence sections. (Courtesy of BH.)

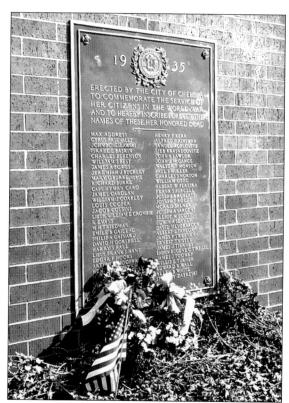

The bronze plaque from the original stadium lists the names of the 58 men and one woman, nurse Mary C. Burke of Chelsea, who died in World War I. The names—Address, Arsenault, Boneslawski, Buckley, Pereira—reflect the diversity of the community at that time. The plaque is now on a brick wall near the new Chelsea High School and stadium. (Author's collection.)

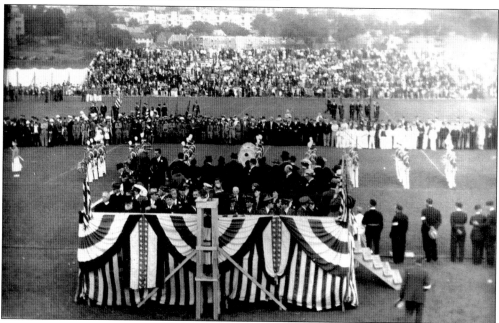

The dedication of the new stadium took place on September 16, 1935, with a crowd of more than 25,000 people attending. Among the prominent guests were the Gold Star Mothers, whose children had given their lives during the battles in Europe. Some 2,000 marchers filed by Mayor Lawrence P. Quigley and honored guests on the reviewing stand. (Courtesy of CPL.)

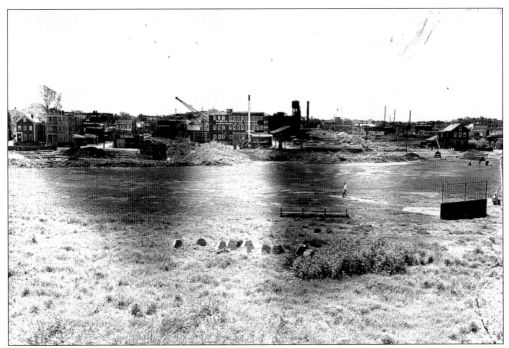

This one last view of the improved Everett Grounds was taken facing toward Carter Street from the parkway. The frame house at the corner of Addison Street is still at the site, as is the small industrial building between it and the Thomas Strahan Wallpaper Company. Much of this expansive view has been considerably obstructed by the expressway, which was built in the 1950s. (Courtesy of JR/CR.)

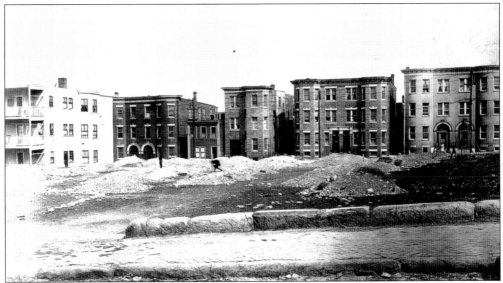

As there were few backyards to play in, city parks were very important for local children. This view of Bosson Playstead was taken in 1926, as work was begun to make it a friendlier neighborhood gathering place. This was the site of Chelsea High School before the 1908 fire. The houses in the background on Grove Street were constructed after the fire and remain there to this day. (Courtesy of CPL.)

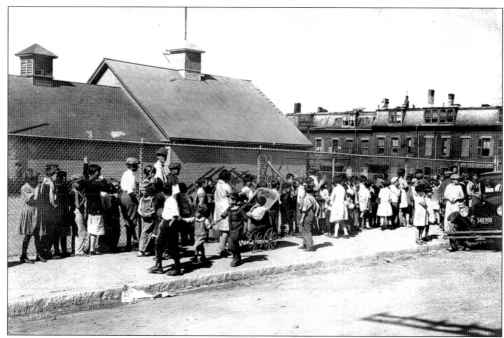

Quigley Playstead was upgraded in 1924, and on opening day children and their parents lined up along Essex Street to get in. One of the buildings on the left remains, as does the row of brick apartments along Hawthorne Street. Previously on the site was the huge granite Marine Hospital, later the first Shurtleff School, which was burned in the 1908 fire. (Courtesy of CPL.)

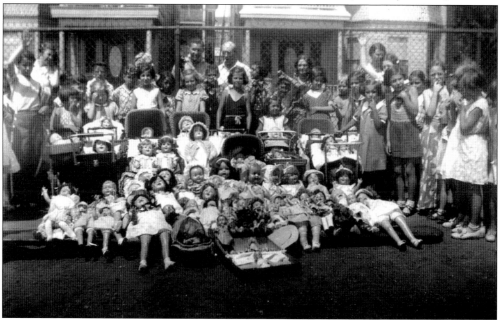

Nothing could be better on a summer's day than a doll show at the park with your friends. Decked out in their finest, these dolls compete in a July 1936 event at Quigley Playstead. The dolls appear prostrate with the heat—hopefully, their little mothers have plenty of lemonade nearby. (Courtesy of CPL.)

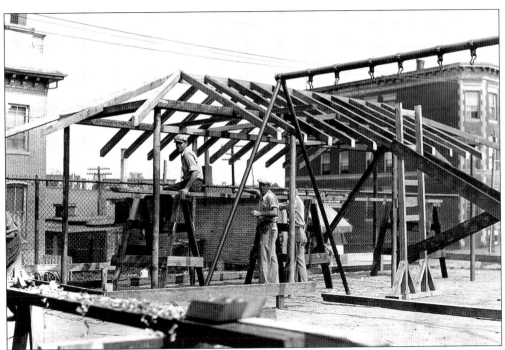

In this 1936 view of the Hawthorne Street side of Quigley Playstead, a shelter is being constructed to protect the children from the summer sun. The house on the left, built in the 1870s, survived the 1908 fire; the one on the right did not and was rebuilt c. 1910. The fire demolished one side of Essex Street, leaving the other side intact. (Courtesy of CPL.)

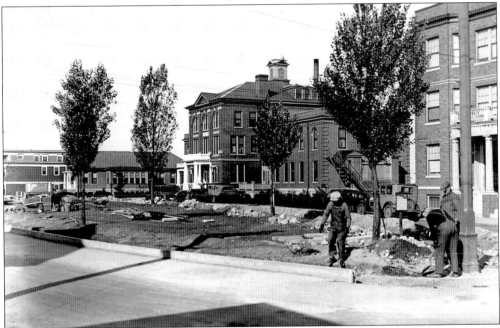

In this laudable effort in the 1930s to spruce up the city, the area in front of the Chelsea Memorial Hospital was beautified with a park, which included new granite curbing, trees, and flowers. The surrounding buildings remain, but the hospital has been demolished. (Courtesy of CPL.)

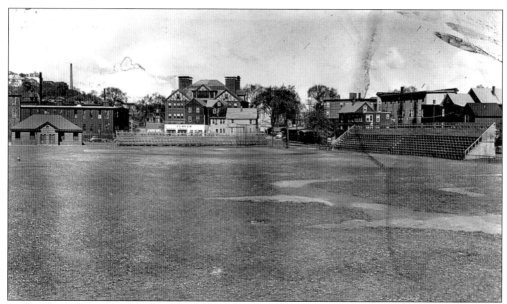

Although the park was not completed until 1936, Marcus Merritt, the ward alderman, secured the land for it in 1912 from the adjoining Revere Rubber Company. Across from the enormous new ball field on Spencer Avenue is the Mary C. Burke School, a handsome English Tudor Revival–style brick, stucco, and half-timbered building constructed in the 1880s. (Courtesy of JR/CR.)

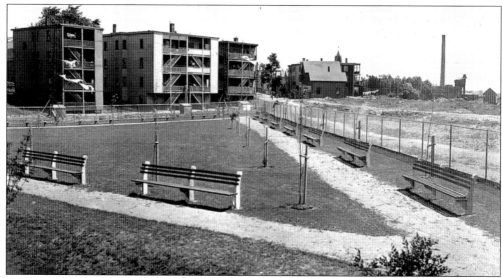

Many of the homes and buildings surrounding Merritt Park still survive—even the old Forbes smokestack in the background of the rest area remains to this day. It took a number of attempts to make this exceedingly swampy area level and dry. Tons of dirt and gravel from nearby construction sites were used as fill for this huge parcel of land. (Courtesy of CPL.)

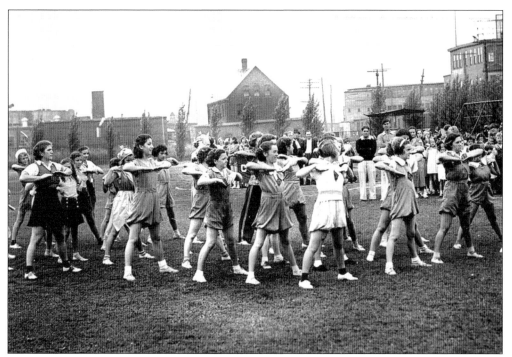

Hundreds attended Opening Day Exercises on September 3, 1936, at the new Merritt Park. Festivities included arts and crafts demonstrations and athletic contests of all kinds. Girls performed gymnastic routines and folk dances; boys played ball and dressed as American Indians, they performed war dances. (Courtesy of CPL.)

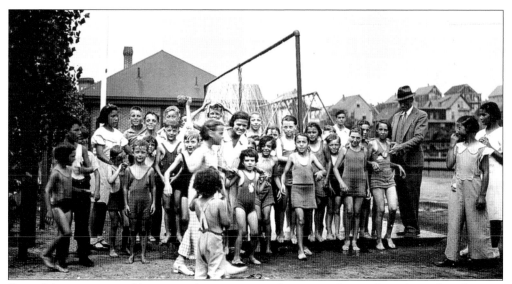

One of the most enjoyable pieces of equipment in the new park must have been the "shower." Large families without automobiles could not easily take their children to the beach, so this must have been a wonderful treat on a hot summer day. Most of the early bathing suits were made of wool, but that does not seem to have dampened the enthusiasm of these children. (Courtesy of CPL.)

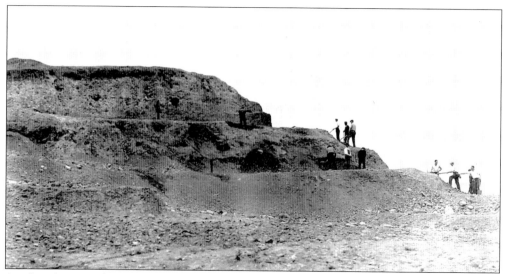

As if working on the Egyptian pyramids themselves, these men have begun the monumental task of developing Malone Park on the top of Powderhorn Hill. Begun in mid-1935, the job required terracing the hill, constructing brick and concrete steps, and laying out paths, trees, and flower beds. Below is the completed park in October 1936. The highest point in the city was a wonderfully cool place for neighbors to gather. As the hill is connected with Revolutionary War history, there may still be historical artifacts buried in it. (Courtesy of CPL.)

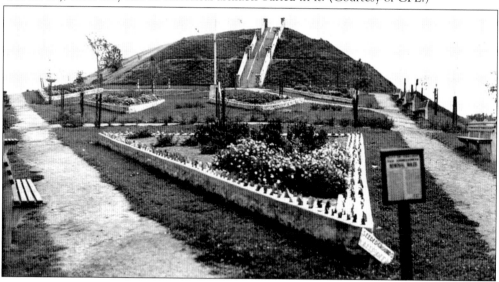

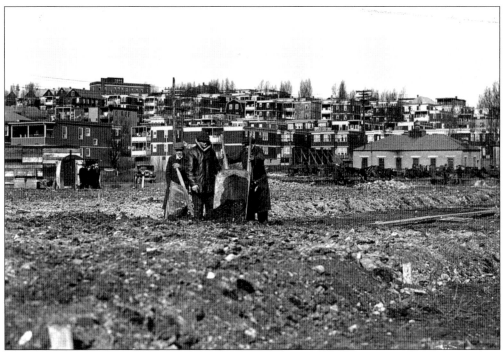

The area at Central Avenue and Highland Street was an eyesore until 1937, when the city was able to use funds from the government to improve the site. It was a tedious job, bringing wheelbarrows of fill in to grade the site. "Before" and "after" pictures show the remarkable improvement in the appearance of the neighborhood, which greatly enhanced the daily lives of its many children who needed a clean and safe place to play. (Courtesy of CPL.)

Blanketed in snow, Prattville's Washington Park is a pretty sight. As an encampment for soldiers during the War of Independence, it had become another dumping ground until rescued by Hermon Pratt in 1885. Later redesigned by William McClintock, city engineer, it has long been a popular spot for neighborhood teenagers, as well as a place for mothers to walk their babies. (Courtesy of CPL.)

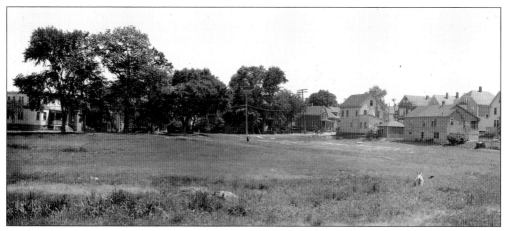

A playground during the day for the younger children, Prattville's Voke Park was also a great place for local teenagers to wile away the long summer nights. The evening often wound up with a walk down to Gallo's Market for a Coke. The park and its surrounding homes look much the same today as in this 1936 photograph. (Courtesy of CPL.)

Five

THE MYSTIC RIVER BRIDGE

"This is the story of a bridge. It's the story of a new, high-level, double decked bridge now being constructed by men and machines over the Mystic River, between the Charlestown section of Boston and the City of Chelsea, Mass. It will be a big bridge. It will be an expensive bridge. It will be the longest structure in New England, measuring 11,900 feet from grade to grade. It will also be built higher than the crow's nest of any ship that has ever used the Mystic River. Directly at this point we could go Hollywood. We could start with adjectives like stupendous, colossal, gargantuan, and so forth. But we won't. We prefer to let the reader judge the magnitude of this piece of bridge construction by the comparisons and the photographs that adorn this brief article." (Jack Scanlon, *New England Construction Magazine*, December 1948.)

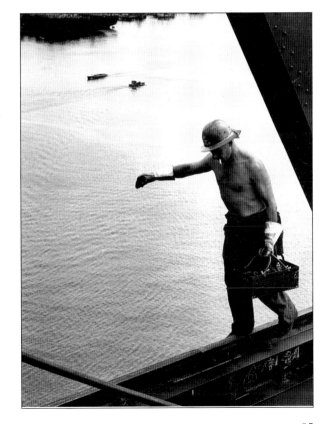

By the mid-1940s, there was an enormous increase in automobile traffic through Chelsea to City Square in Charlestown. Backups were legendary. It was no longer possible to ignore the inevitable; a new bridge had to be built. To avoid the cost of such an undertaking falling to any particular community, the Mystic River Bridge Authority was formed in May 1946. The $27 million cost for the high-rise bridge was to be raised by issuing revenue bonds to private investors. The authority was charged with both building and operating the bridge. (Courtesy of Massport, hereinafter referred to as MP.)

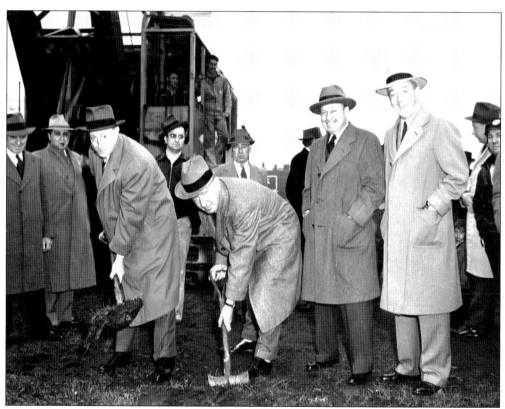

Digging in at the groundbreaking are four members of the authority, including its chairman, Ephraim A. Brest, center. Brest was born in Chelsea and was a star on the high school football team. He went on to become a prominent attorney, as well as a director of several large Massachusetts business firms. He and other members were appointed by the governor of the Commonwealth. (Courtesy of MP.)

These two photographs were taken at the start of the bridge project in mid-1948. Materials have begun to arrive, and surveying is in progress at the lower Broadway entrance to the Naval Hospital. A single-decked bridge was considered, but would have required more land taking to accommodate the number of lanes necessary for incoming and outgoing traffic. A two-level bridge would be narrower, hence taking less land and also eliminating the possibility of head-on crashes. Serious consideration went into all aspects of this monumental project. (Courtesy of MP.)

Preparation continues, as a road is cleared between buildings for use by construction vehicles. The handsome three-story mansard-roofed house was demolished, but the granite posts and cast-iron fence to its left still survive. They remain there today, next to the Polish Political Club, on lower Broadway. (Courtesy of MP.)

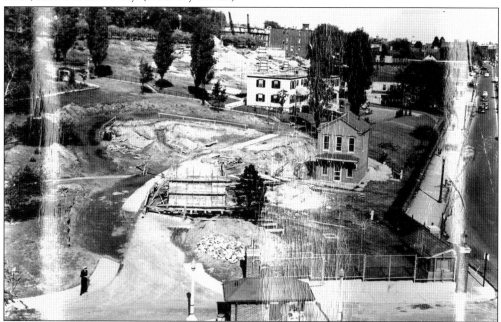

By October 1948, the impact of the project is becoming clearer. Life seems to go on as usual, however, as a sailor waits by the corner and traffic along Broadway heads toward the old bridge to Charlestown. The bridge in use then was a swing bridge rather than a drawbridge—it was swung aside as needed for ships to pass through. Repeated openings throughout the day created increasingly long delays on both sides. (Courtesy of MP.)

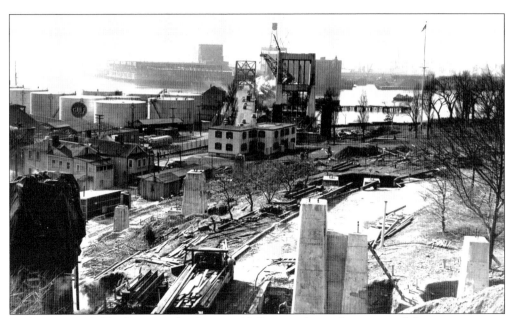

Looking toward Charlestown, this January 1949 view shows that many of the concrete piers to hold up the new steel bridge have been set in place. A total of 33 sets of foundations were eventually laid, and those in the water rested on bedrock at the bottom of the river. Great care had to be taken not to damage the existing bridge, which remained in operation while the Mystic River Bridge was constructed. (Courtesy of MP.)

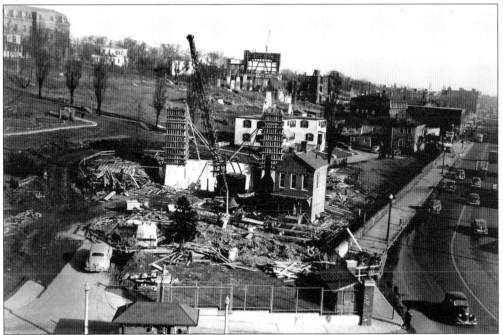

Another dramatic view in January 1949 looks toward the Naval Hospital Hill, with Broadway at the right. The 1820 tollhouse, near the busy road, had certainly been witness to enormous changes in this once quiet city. The house is an important link to the past that hopefully will survive well into the future. (Courtesy of MP.)

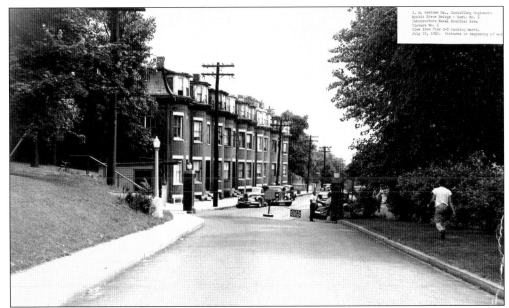

These beautiful brick bow fronts, at the entrance to the Naval Hospital on Chestnut Street, were photographed in July 1948, just as the bridge project began. As handsome as any in Boston, they probably date to the 1870s. Within six months they were overwhelmed by their new neighbor. Like Sherman's troops marching to the sea, the bridge moved through the city, and these homes had to be demolished. (Courtesy of MP.)

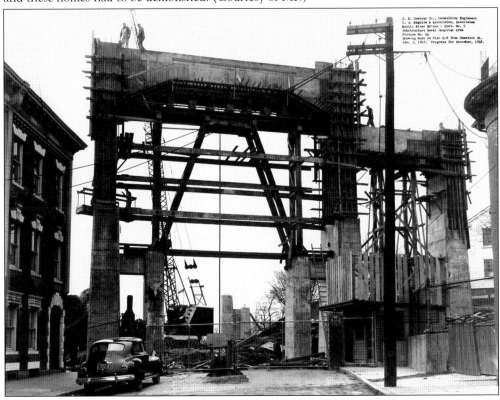

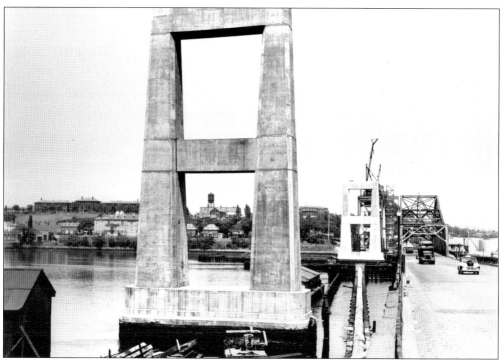

More dramatic views were taken in the early spring and summer of 1949. The past and present combine, as the new and old Naval Hospital buildings look down over the new and old bridges. The Mystic River Bridge, 135 feet above the water and two miles long, is twice as long as both New York's famous Brooklyn Bridge, and the Golden Gate Bridge in San Francisco. Below, the tollhouse and row houses along Broadway are dwarfed by the towering piers. (Courtesy of MP.)

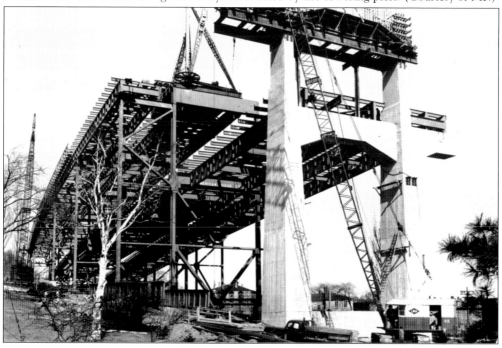

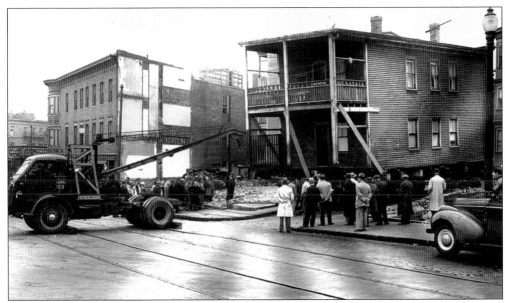

Not far away on Poplar Street, homes in the path of the bridge are being lifted off their foundations and moved to Webster and Clark Avenues. In this November 1948 photograph, a two-family house is making its way onto Everett Avenue to ready it for its ride across town. Setting something of a record, 55 homes were moved in 55 days. Tirck's Pharmacy is at the left, located on the corner of Walnut Street. (Courtesy of BH.)

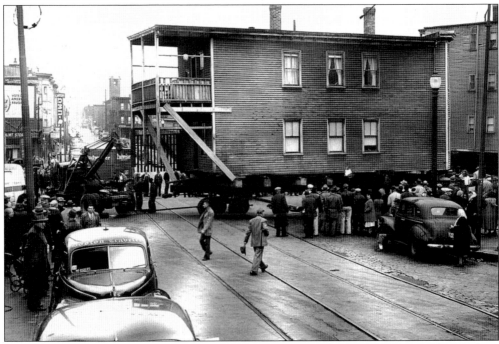

This is another view of the house moving, which was accomplished with curtains at the windows and furnishings left inside—definitely a crowd-gathering opportunity. A view of the once bustling ethnic neighborhood along Everett Avenue is visible at the left. The tower in the distance was part of the fire station, which survives today as the Winter Hill Bank. (Courtesy of BH.)

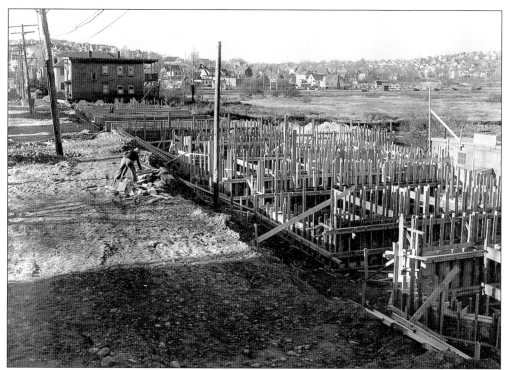

Across town on Webster Avenue, foundations are being set in place for the homes that are to be moved there from Poplar Street. Notice the vast area that once was the infamous clay pit, which later became a shopping mall. The Locke Street housing was not built until a few years later. (Courtesy of Joseph Monzione and Steven Monzione of Hawthorne Studio, hereinafter called JM/SM.)

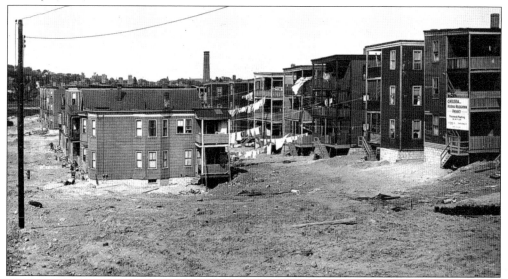

These are the homes that were relocated to Gilooly Road and Clark Avenue. Although the area was less congested than the narrow old Poplar Street had been, it was far from the downtown, very dirty, and unfinished. It must have been something of a shock to be dropped down in the middle of it. All the homes remain on this site today. (Courtesy of JM/SM.)

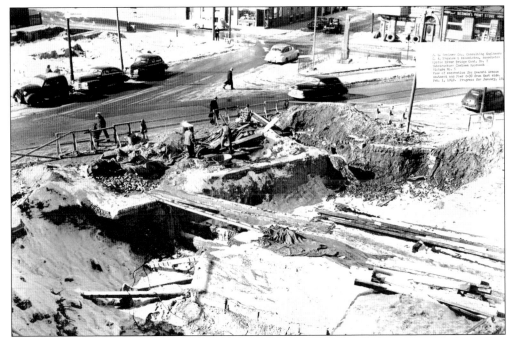

At the right is a good view of Max Address Square, which was dedicated to Chelsea's first Jewish casualty in World War I; behind it is Berman's Paint Store. This intersection of Third Street and Everett Avenue no longer exists. In the foreground is Poplar Street between Walnut and Chestnut Streets, which was all but obliterated by the construction of the bridge. A small section of the street remains between Fifth and Sixth Streets. (Courtesy of MP.)

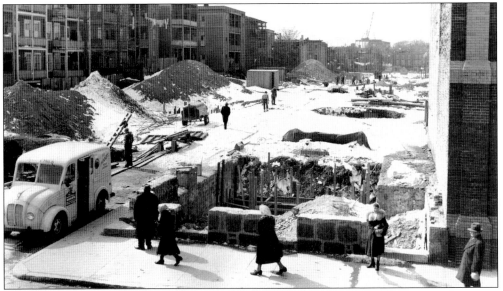

This photograph was taken from the house at 65 Fourth Street in March 1949. People appear to take everything in stride as they walk along Fourth Street, passing the empty land that was once Poplar Street. The familiar Hood's milk truck makes its rounds, and life goes on. Spared demolition was Congregation Agudas Sholom, at the far right, facing Walnut Street. It is Chelsea's oldest active synagogue. (Courtesy of MP.)

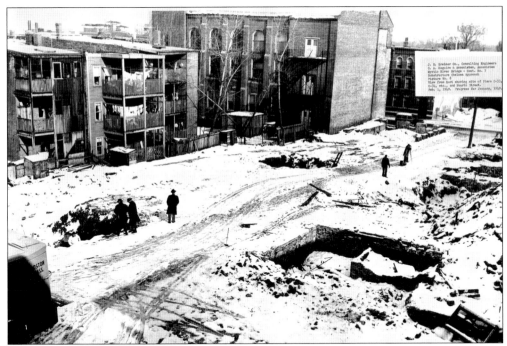

Another view along the path of the bridge shows the back and side of the synagogue, along with its neighbors on Walnut and Fourth Streets. The massive holes for the piers look as if a giant had walked through town. Below, the original entrance ramp from Fifth Street cuts across the sky, as one looks from Walnut Street toward Broadway. Through traffic from Walnut Street to Broadway continued for a while but proved too dangerous. (Courtesy of MP.)

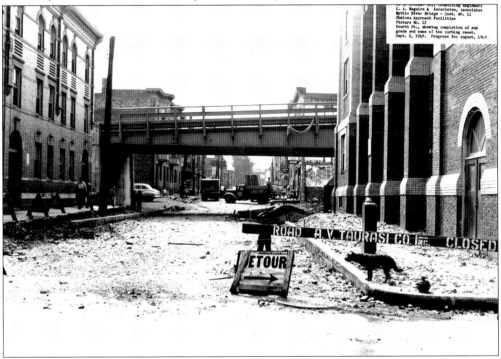

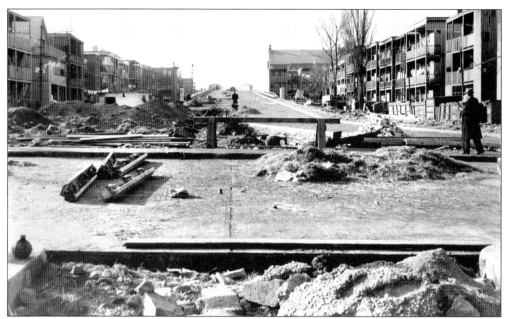

By January 1950, the pavement was nearly completed on the Fifth Street ramp, one of the entrances to the new bridge. The formal opening was just a month away. Only a few years later, the bridge was extended by the expressway, making an even greater impact on the landscape of this small, densely populated community. (Courtesy of MP.)

A very quiet day at the bridge entrance ramp on Fifth Street was captured in this photograph from December 1950. What remained of Poplar Street is in the center, with the stone Salvation Army church and Chestnut Street to the right. Like many projects, debris from the construction seems to have been forgotten by the side of the road. With the exception of a few homes on Poplar and Chestnut Streets, all of the buildings in this photograph have since been demolished. (Courtesy of BH.)

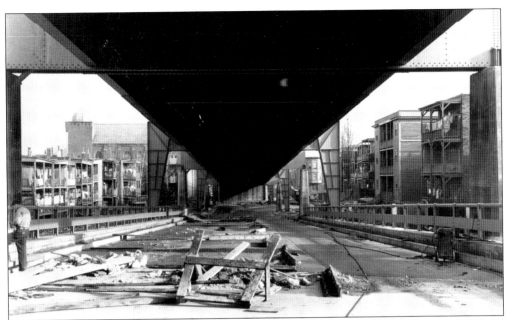

Aside from some cleanup, the Fourth Street exit ramp was also completed by January 1950. By this time, the view of the bridge from one's back porch had become a reality. There had been many objections to the construction of the bridge, but the desire to bring new business to the city won out. The 1950s were a decade of progress; it was hard to foresee what the impact of some decisions would be. (Courtesy of MP.)

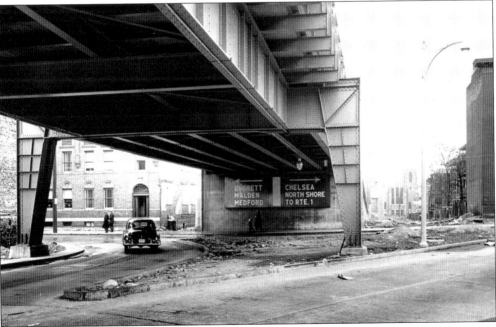

There was serious concern regarding the automobiles' hasty exit into the busy intersection at Fourth and Chestnut Streets; so, traffic signs, lights, and local police were added to the area. Nevertheless, the abrupt exit caused so many accidents that the ramp to Walnut Street, which exited near Williams School, was eventually closed. (Courtesy of BH.)

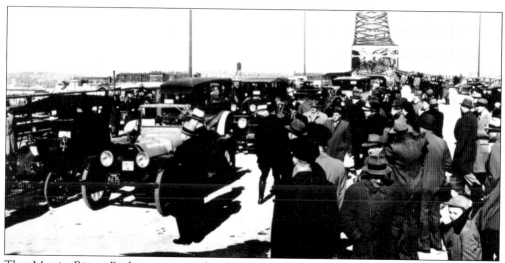

The Mystic River Bridge was completed in mid-winter, two months ahead of schedule. Numerous festivities celebrated the opening. Local residents had a day to drive and a day to walk the new structure, as stores along Broadway decorated their windows and had special sales to entice people who came to see the new bridge. On opening day, February 28, 1950, a fleet of antique automobiles led the celebration, rumbling over the new concrete; ship and factory whistles blew, and fireboats spouted streams of colored water. (Courtesy of MP.)

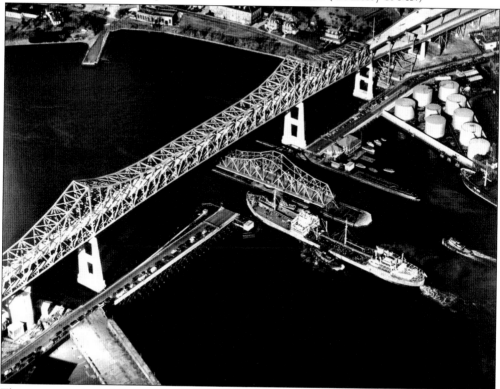

This is a rare view of the new and the old bridges, side by side. Dwarfed by its successor, the swing bridge lets one last ship through before it becomes another chapter in Chelsea's long history. (Courtesy of MP.)

Six

THE NINETEEN FIFTIES

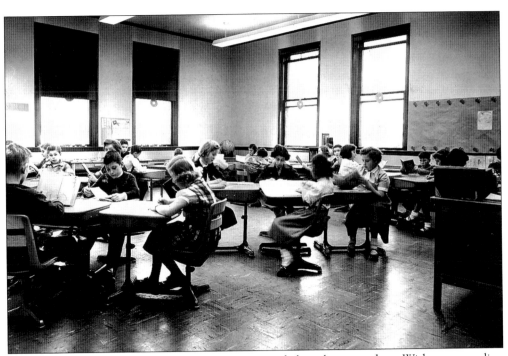

The 1950s were all about progress and prosperity, and about being modern. With overcrowding at Prattville School, some elementary classes were held in classrooms at Chelsea High School. This classroom was outfitted with newer equipment than most schools, such as movable desks, new floors, and updated fluorescent lighting. It was the beginning of a greater concern for the impact that the physical plant would have on the ability of the children to learn. A school department report asserted, "This new physical environment will undoubtedly help to improve educational outcomes." A few television sets were purchased, and the school committee was "commended for its foresight in preparing so well for this coming teaching medium." (Courtesy of BH.)

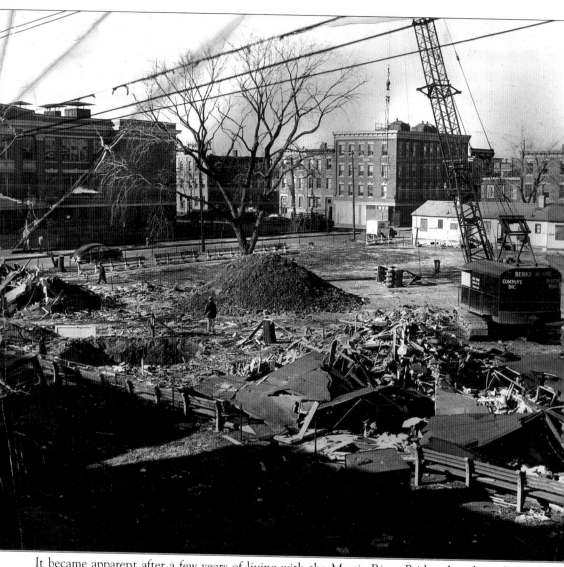

It became apparent after a few years of living with the Mystic River Bridge that the volume of traffic making its way through the narrow streets of Chelsea was hazardous. This January 1955 photograph was part of a news article that described the clearing of land that was to be used for the construction of the Northeast Expressway. The expressway was to extend from Boston to the North Shore, so that the ever increasing number of automobiles would not have to drive through Chelsea. The land clearing was much more destructive to the city than the bridge project had been, removing many homes while leaving dark, inaccessible pockets of land

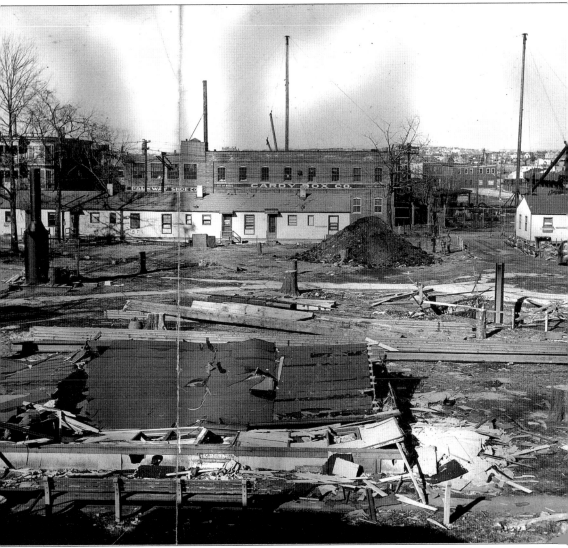

underneath. It was the same time that the Central Artery in Boston was constructed, splitting that city in two. By 2004, the artery has been almost totally removed, rerouting the traffic underground and allowing Boston to knit itself back together. City planners in the 1950s often did not take into account the toll that neighborhoods would pay for progress. With the old Williams School and most of early Arlington Street gone, all that remains here from the past is the brick building of the former Parkway Shoe and Cardy Box Company. Hopefully, it will continue to stand its ground. (Courtesy of JR/CR.)

This is a view from the bridge to the playground at the corner of Walnut and Second Streets. For a long time, this was the home of the beautiful early-19th-century Cary School. In the 1950s, this treeless, hot-topped land was the play area for many children in the surrounding tenements, whose backyards were only large enough for a few trash barrels. This neighborhood is entirely gone; the Kayem Company occupies most of the space. (Courtesy of JR/CR.)

"Life in the Fast Lane" was the title the *Boston Herald* gave this photograph of Helen Taylor, whose "neighbors," it said, "are all the motorists in the passing lane along Route 1 from Revere to Chelsea." The Walnut Street Synagogue appears on the other side of the roadway. (Courtesy of BH.)

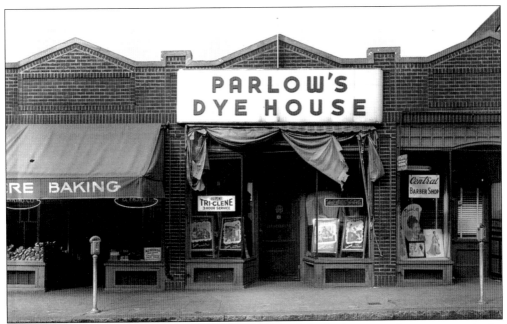

Across town on Central Avenue, where the impact of the highway was less apparent, is the 1950s version of the neighborhood strip mall. Without need of a car, you could pick up some fresh bulkie rolls, drop off your cleaning, and get a haircut. Life could not be much easier than that. (Courtesy of called JM/SM.)

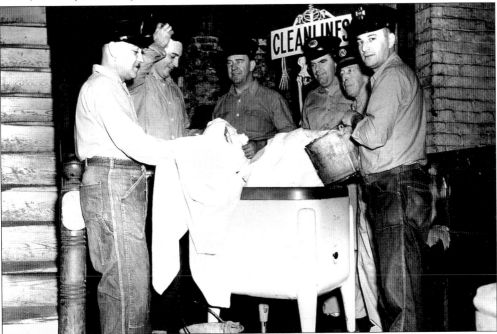

In the event you could not leave the neighborhood, you just might have to take care of some things right where you were. These firemen at Engine No. 3 appear to be doing their own laundry, using the still-popular wringer washer at the station. Perhaps this led to an interest in adding women to the department. (Courtesy of JM/SM.)

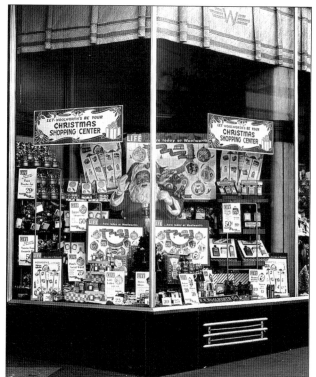

F. W. Woolworth's window proclaims itself as "Your Christmas Shopping Center." The prices are certainly right, with Mennen Gift Sets at $1.19 and Tangee Beauti-Sets at just 50¢. Blue Waltz perfume was also a popular gift for mothers. At one time, Broadway had three thriving five-and-ten-cent stores: Woolworth, W. T. Grant, and J. J. Newberry. (Courtesy of JM/SM.)

Here the traffic is coming off the Fourth Street bridge ramp onto the still-cobblestoned Broadway. Spencer Shoe's elegant Art Deco sign is at the left corner, with the rear door of Clear Weave along the side of the building. Across the street is Chelsea's first Stop & Shop supermarket; the sign shows an upraised hand symbolizing Stop and a market basket symbolizing Shop. (Courtesy of BH.)

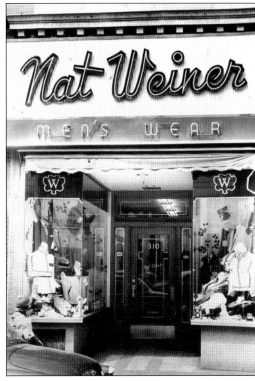

As noted earlier, Broadway was a place of specialty stores, and Nat Weiner's was popular with the well-dressed men of the city. The attractive window display and impeccable interior were typical of the times. At 310 Broadway, Weiner's had a neon sign that would light up on Friday nights, when stores remained open until 9:00 p.m. Sometimes it seemed as if the whole city were out on the streets on Fridays. (Courtesy of Goodell Photo, JR/CR.)

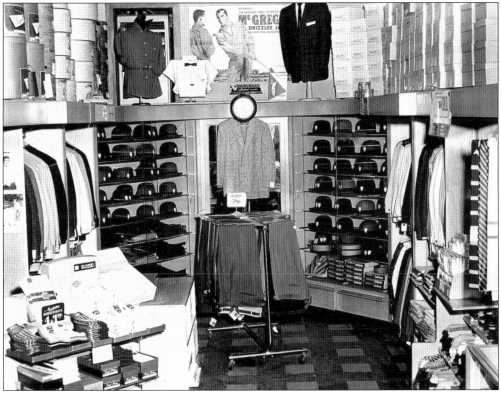

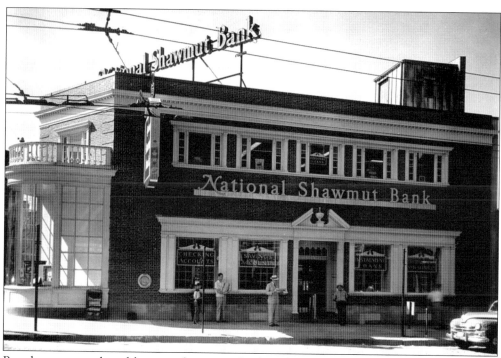

Broadway was anchored by two of its many banks. The National Shawmut Bank was at the Chelsea Square end for many years, with its handsome bronze American Indian statue in the window. The 1940s Art Deco building of the Broadway National Bank, below, which the Tierney family served for many years, held court in Bellingham Square. The building lot is now vacant, the bank having moved to a modern facility at the corner of Bellingham Street. (Courtesy of JR/CR.)

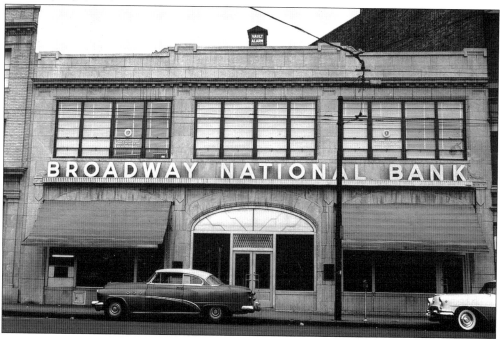

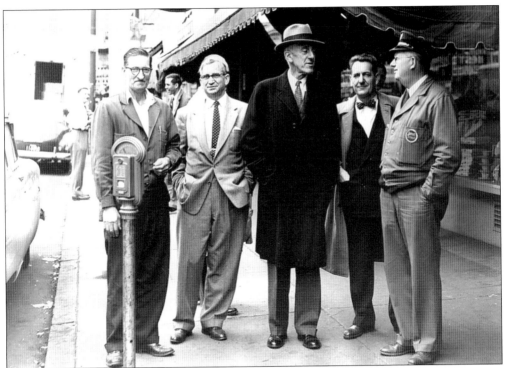

Another reason to go downtown was to see and be seen. Here, senatorial candidate Leverett Saltonstall, center, is being introduced by well-known resident and lifelong Republican Clifton Clarke, sporting the bow tie. A handshake and a few appropriate words went a long way along Broadway. Gorin's large neon sign can be seen just over the head of the gentleman at the left. (Author's collection.)

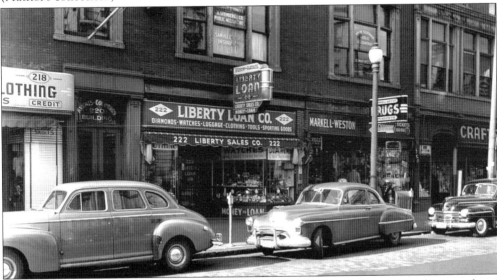

The stores in Chelsea Square were often smaller than, and did not have quite the panache of those in the newer end of Broadway. However, from Liberty Loan and Dalis' Diner on one side to Resnek Drugs and Chelsea Tire and Cycle on the other, they remained an important part of this diverse and remarkable cityscape. (Courtesy of JM/SM.)

Numerous informal gatherings were photographed, as life went on around the city. The street corner pictured above in 1957 is unrecognizable today, although the same buildings remain at the corner of Congress Avenue and Division Street. A curious crowd gathers for activity of a different nature at the Harmony Cocktail Lounge, on Fifth Street, below, which exhibits one of the city's handsomest neon signs. (Courtesy of BH.)

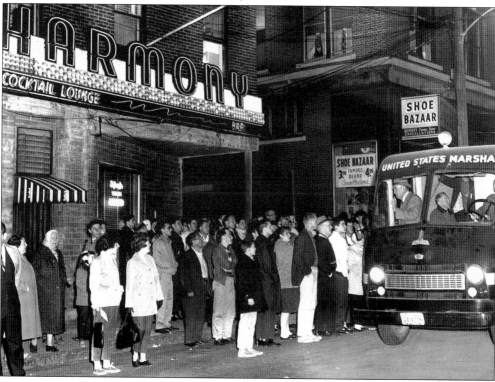

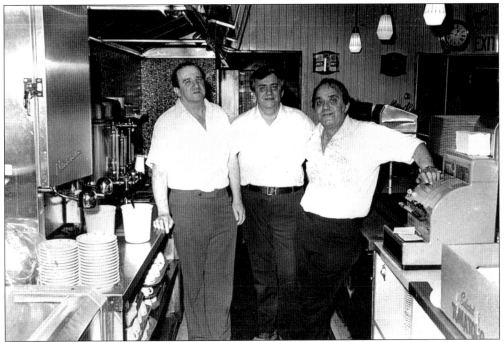

The Rosenberg brothers stop to catch their breath and pose for the camera in the midst of a busy day at Murray and Eddy's Deli on Broadway, another of Chelsea's sadly missed delicatessens. All decked out for a good time, the anonymous but happy party of celebrants below is ringing in the New Year in 1955. Hopefully, this photograph will bring back fond memories to some of the participants in this genial group. (Courtesy of JR/CR and Goodell Photo.)

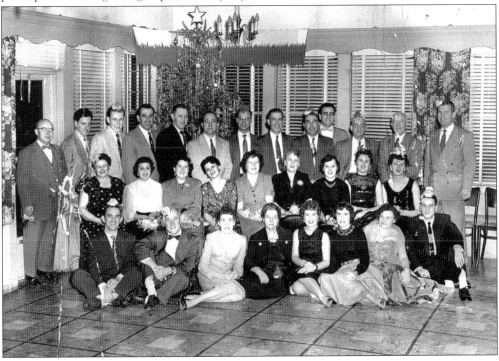

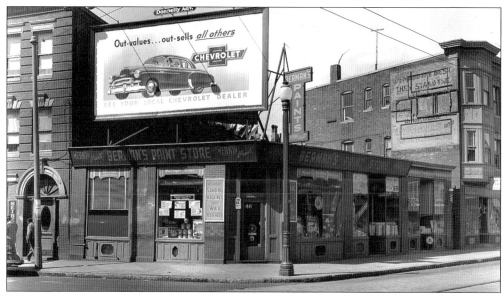

For diversity, it would be hard to beat the exciting activity along Everett Avenue and its surrounding streets. At the intersection of Third Street, which no longer exists, was Berman's Paint Store; alongside it was a barbershop and the Star Heating Company. Star Heating is still in business today, farther down Everett Avenue. Although television was still a new medium, billboards and painted walls remained common ways of advertising. (Courtesy of JM/SM.)

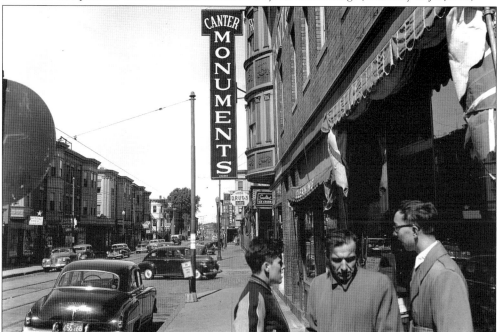

Across Everett Avenue, at the corner of Walnut Street, was Canter Monuments. For decades, thousands traveling on the bridge were cautioned by their painted wall sign that read, "Drive Carefully, We Can Wait." Tirck's Drugs, at the opposite corner of Walnut Street, was a good place to stop for an ice cream on your way home from Williams School, as most drugstores also had a soda fountain. (Courtesy of JM/SM.)

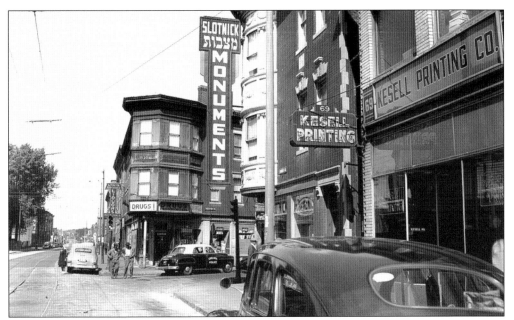

A little farther down the avenue toward the Revere Beach Parkway was Slotnick Monuments. There were many signs in Hebrew on the stores in this once primarily Jewish neighborhood. Kesell Printing Company has since moved, but part of the block containing number 69 is still there. At the corner of Arlington Street is one of Chelsea's finest, in an old black-and-white police car. (Courtesy of JM/SM.)

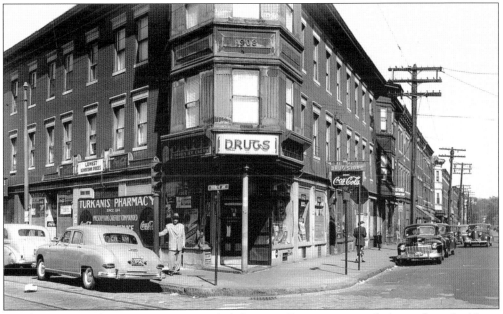

At the corner of Everett Avenue and Arlington Street is one of the earliest buildings constructed after the 1908 fire—the date is above the second-floor window. The building was also photographed c. 1910 and can be seen on page 30. Among other stores was Turkanis' Pharmacy, at number 73, not to be confused with Tirck's, which was a block away. The neighborhood then resembles many that still exist in New York. (Courtesy of JM/SM.)

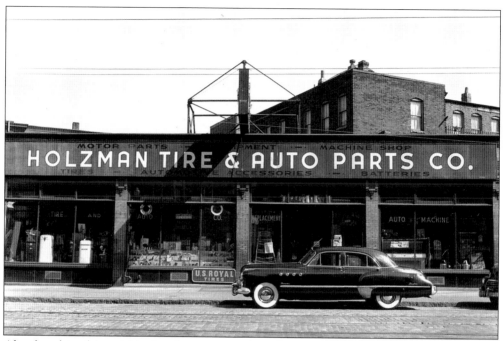

Also found in this neighborhood were a number of automobile-related businesses, Holzman Tire & Auto Parts being one of the largest. Amazingly, the building is still there, at 57–59 Everett Avenue. It was good advertising to have a handsome, late-model automobile parked out front, such as this whitewall-tired Buick Dynaflow. (Courtesy of JM/SM.)

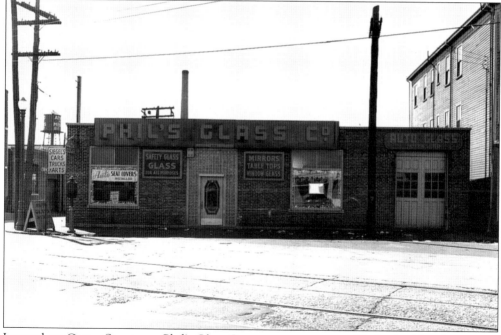

Located on Carter Street was Phil's Glass Company, now among Chelsea's oldest businesses. Begun in 1938, it is now J. N. Phillips, and although remodeled, it remains in its original location. (Courtesy of JM/SM.)

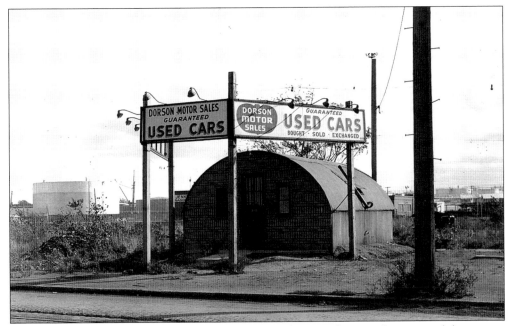

Car culture developed in the 1950s, and many people aspired to purchase one of the newest models at the big fancy showrooms of Chelsea Chevrolet or Ullian Buick. That not being possible, one might have to settle for an affordable alternative down at Dorson's. At least they were guaranteed. (Courtesy of JM/SM.)

Many of those once shiny new automobiles eventually ended up here, along with old boats, washing machines—just about everything, including the kitchen sink. It was not a pretty sight, but wise Chelsea businessmen saw the value in recycling well before it became a necessity. (Courtesy of JR/CRSM.)

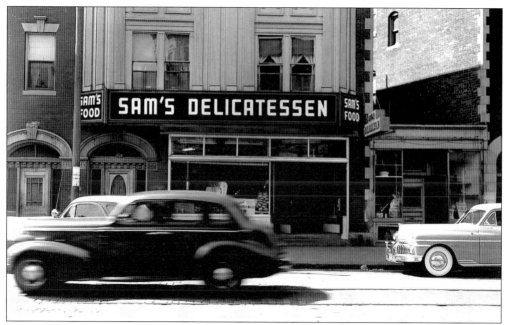

Ah, those delis—one of the special things about Chelsea that is sorely missed today. Sam Pressman ran this one on Everett Avenue. Former resident Jerry Harris wistfully recalls the sandwiches piled high with corned beef, a favorite late-night snack after a date or a ball game. Most days, the slicer was running, and the place was filled with hungry customers until 2:00 in the morning. (Courtesy of JM/SM.)

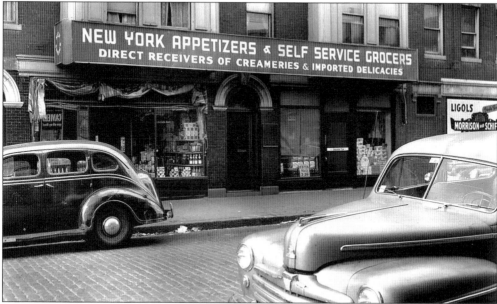

Around the corner on Arlington Street was New York Appetizers and Grocers, where the shelves were stocked with specialty foods, in demand for the Jewish holidays. People came for miles to purchase Kosher delicacies. Edna Chesna Serino still has fond memories of the barrels of pickled tomatoes, smoked whitefish, and half sour pickles that stood outside the store. (Courtesy of JM/SM.)

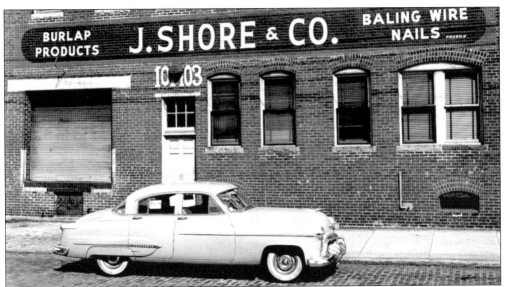

J. Shore & Company, sporting a handsome Oldsmobile Futuramic out front, is one of the very few early industrial buildings that remain along Second Street today. Hopefully, it will survive into the future as a reminder of the noisy, bustling world that once was Second Street. It is now Atlantic Clothing Corporation. (Courtesy of JM/SM.)

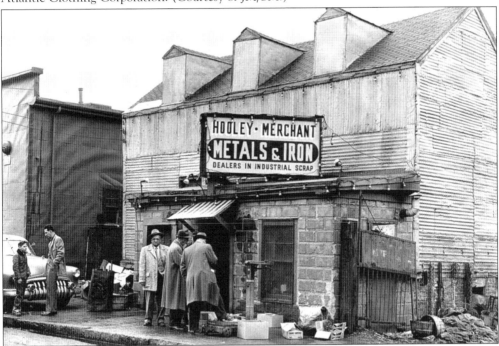

The scrap metal business of Hooley-Merchant, on Second Street, was photographed by the *Record American* after a 1957 armed robbery. The owner's 12-year-old son, Robert Merchant, on the left, was a witness as Hector Merchant fired at the two men who fled in his car. This business, like many others in the area, was located in a building that had once been a private home. The dormers on its roof were at one time someone's bedroom. The business remains at this site. (Courtesy of BH.)

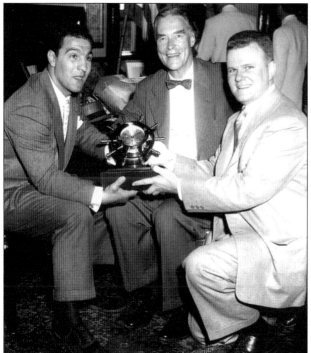

Photographed by the Hawthorne Studio, boxer Rocky Marciano, left, poses with Gov. Christian Herter and Mayor Andrew Quigley. To celebrate his retirement in 1956 as undefeated heavyweight champion, Marciano was given the gift of a Chelsea clock and an enthusiastic and well-attended parade along Broadway. (Courtesy of Hawthorne Studio and JR/CR.)

In 1955, the Chelsea Memorial Hospital Aid Association presented new equipment to the hospital that was so much a part of the lives of Chelsea residents. As most women did not work outside the home at this time, there were many volunteer opportunities for them to help in schools, churches, and other local organizations. Gloves and hats were still the order of the day. (Courtesy of Goodell Photo and CPL.)

Many have passed through this well-worn door to the Hawthorne Studio, home of Chelsea's oldest and most popular photography business. Originally located at Hawthorne and Pearl Streets, the studio was begun in the 1930s by portrait master Chester Titchell. The business later went to his son and, in 1978, was taken over by Steve Monzione, whose father, Joseph Monzione, was also a photographer. It remains a popular professional studio of specialized artistic photography in its new location, the handsome old Masonic Building on Broadway. (Photographed by Joshua Resnek of the *Chelsea Record*.)

Smiling for the camera, members of the antiques group of the Chelsea Woman's Club, some in costume, pose with their collection of teapots. An important social organization, the club began in the late 19th century and included the wives of many of the city's business leaders. (Courtesy of the CPL.)

In October 1957, Chelsea held a huge parade in celebration of the centennial of its birth as a city. The float sponsored by St. Stanislaus Church depicts the Revolutionary war hero Polish Gen. Casimir Pulaski. It was always a treat to see the pretty little girls in their traditional velvet-topped dresses, decorated with bands of colorful ribbons. A good view of the Apollo Cafeteria and a bit of Freeman's Drug Store, at the corner of Fifth Street, are in the background. (Courtesy of BH.)

To the cheers of the crowd, the parade makes its way along Broadway to the intersection of Everett Avenue and Cross Street. Next to the once beautiful Strand Theatre, in the background (playing a James Arness movie), is the Broadway Tower, one of the little hamburger places that preceded the large chains that replaced them years later. (Courtesy of JM/SM.)

Into Chelsea Square the parade goes, the Knights of Columbus float passing the Morgan Memorial Store and bowling alley. The Winnisimmet Loan Company and the Chelsea Tire and Cycle, in the old Gerrish Block, are in the background. The line of parked cars should be a treat to the eye of many who find them a wistful reminder of times past. (Courtesy of JM/SM.)

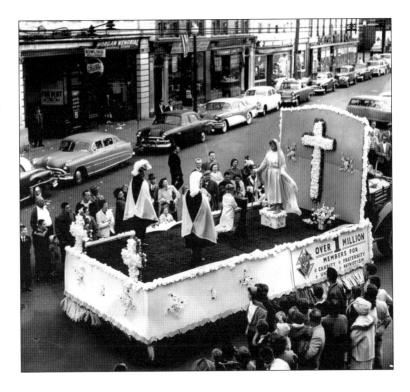

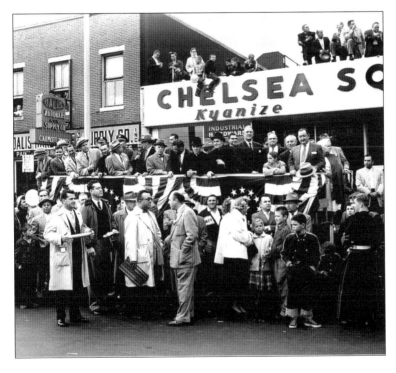

Anticipating the arrival of the parade are local dignitaries on the reviewing stand in front of the Chelsea Square Hardware store. Fifth from the left, wearing a light colored hat and topcoat, is Mayor Hugh McLaughlin. McLaughlin served many years as an alderman before being elected mayor, a position he held from 1956 to 1959. He succeeded Andrew P. Quigley's four years in office. (Courtesy of JM/SM and the CPL.)

In December 1953, school buses lined up in front of Chelsea's "overcrowded and ancient Prattville School," as it was described in a *Boston Traveler* news article. Fifth- and sixth-graders were being bused to temporary classrooms at the high school, as this "ancient" school was experiencing a serious overcrowding problem. (Courtesy of BH.)

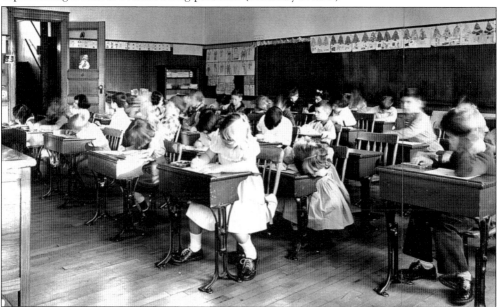

Calling attention to the "old-fashioned desks and lighting fixtures," the article went on to explain that Prattville School was overcrowded, while Williams School was "empty." The school population had shifted, as a number of children were relocated after their homes were demolished for the building of the Mystic River Bridge. A Harvard research group working on a study of the problems suggested an upgrade at Prattville to the kind of modern classroom that was available at the high school. (Courtesy of BH.)

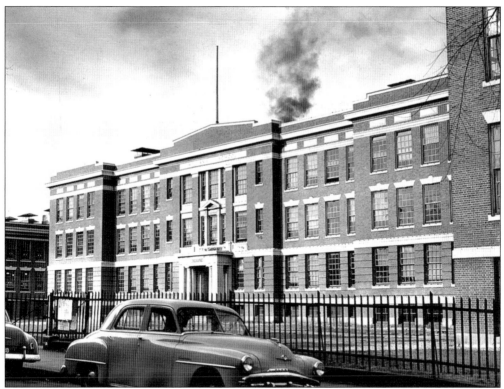

The much beloved and still missed old Williams School, on Walnut Street, looks down on us one more time. New students were known to get quite lost in this huge complex, with its long corridors that traversed the two additional wings. Drawing from the dense, multiethnic neighborhood surrounding it, Williams had a large student population, which included remedial classes, an early attempt to assist the learning disabled. (Courtesy of BH.)

One of the real joys for Williams girls was singing in the Williams Junior High School Glee Club. Club leader Alvin Toltz, in the back left, and Headmaster Joseph Cotter stand on the stage in the auditorium-gymnasium with those fortunate enough to have made the club. Each girl had to audition and was chosen and placed according to her voice. There were some outstanding young singers among the girls, and they practiced long hours in order to enter local competitions. (Courtesy of JM/SM.)

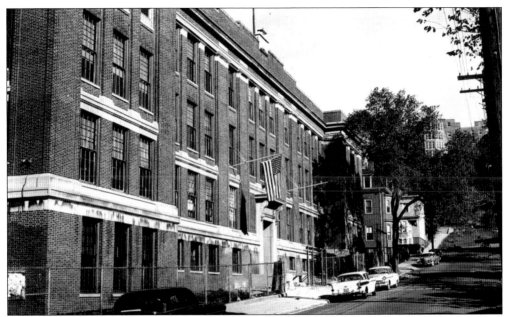

Photographed in the mid-1950s, the Carter School, on Forsyth Street, held grades one through nine. Its devoted headmaster for many years was Joseph P. Schultz, who was truly heartbroken when the school burned down in the early 1970s. Ninth-grade graduation from one of the three local junior highs was an exciting and important event. Celebrations after graduation exercises usually included a night of fun at Revere Beach, with all the food and rides one could want. (Courtesy of the CPL.)

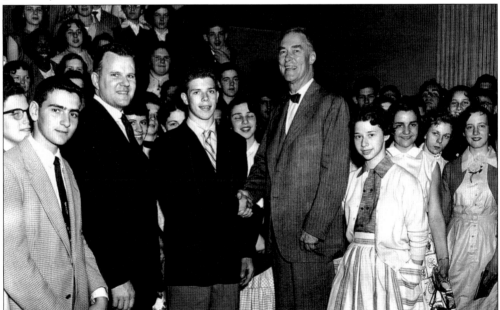

A field trip to Boston's beautiful State House finds Michael London, Carter class president, shaking hands with Gov. Christian Herter, as Mayor Andrew Quigley and London's classmates look on. Suits for the boys, dresses for the girls, and neat haircuts for everyone were the order of the day in the 1950s. (Courtesy of the CPL.)

When basketball season began at Chelsea High School, the players and their fans were packed into what had to be one of the country's smallest gymnasiums. With players pressed against the walls and the crowd elbow to elbow in the overhead gallery, the games were close in more ways than one. Regardless of the size of the gym, coach Sol Nechtem and his boys provided many exciting moments on the court. For years, the highly anticipated school proms were also held in this gym. (Courtesy of BH.)

"Hit the showers," called the coach after the game was over; unfortunately, this is where the team headed. The *Boston Traveler* newspaper printed this photograph in 1953 to call attention to the inadequate shower facilities, as well as the tiny gymnasium at the high school. A Harvard study suggested either building an entirely new gym or turning the present high school auditorium into a gym. However, like Chelsea itself, for all its faults, residents loved it still. (Courtesy of BH.)

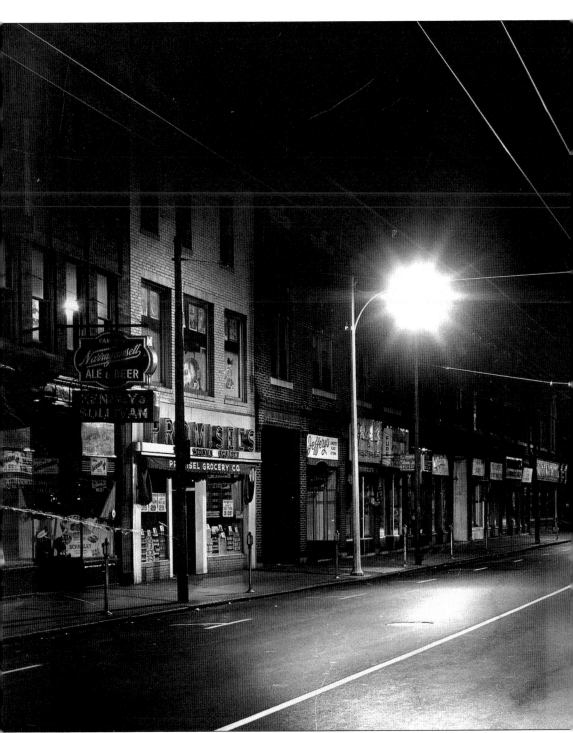

Broadway holds some of our fondest memories. To complete this history of Chelsea in the 20th century, we have two long, last looks at Broadway in the late 1950s. These nighttime shots from Bellingham Square include Promisel's Grocery Store, along with the many small specialty shops, such as Wheeler's Dress Shop and Hattie's Hat Shop, on the left side of the street. On the

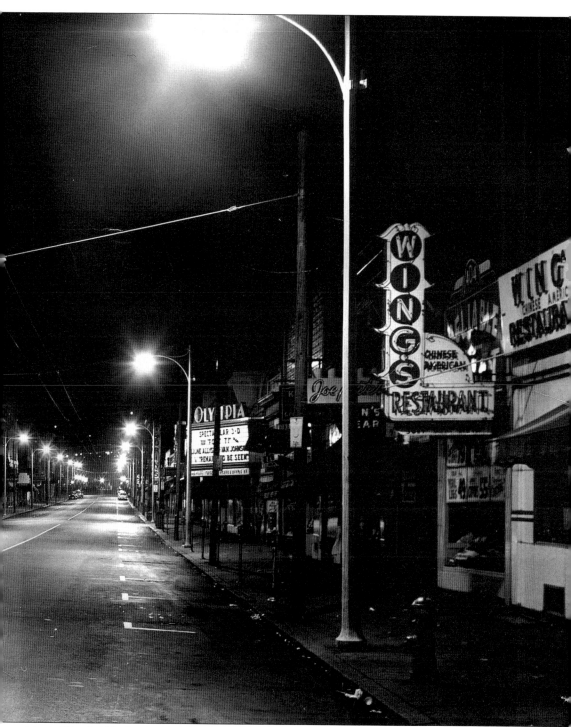

right is Wing's (Chelsea's oldest restaurant), the Reliable Market, Joe Porter's Clothing, Debby Shops, and the Olympia Theatre. For some, the best times of all were on Friday, the high school crowd's night at the movies, followed by a trip to Tony's Spa. (Courtesy of JR/CR.)

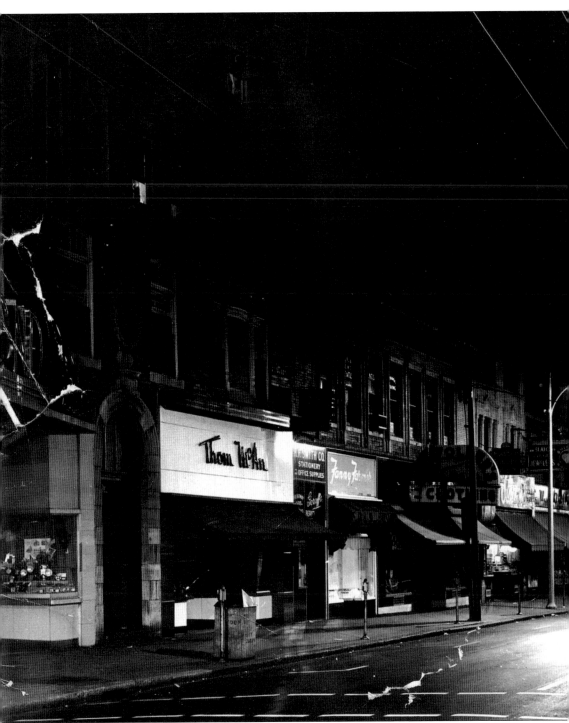

From Congress Avenue and Third Street, you could wander into Pond's Jewelers, Thom
McAn's, Fanny Farmer's, Gorin's, or one of the city's finest shops, Wolper's. Many had their
first jobs at the five-and-tens—Woolworth's, Grant's, or Newberry's. There was even a popular
bowling alley on the second floor above one of the department stores. When stores were open